ROTOVISION
PRO-PHOTO SERIES

Close-Up
Photography

Jonathan Hilton

pro
photo

A RotoVision Book

Published and distributed by RotoVision SA
Rue Du Bugnon 7
CH-1299 Crans-Près-Céligny
Switzerland

RotoVision SA, Sales and Production Office
Sheridan House, 112/116A Western Road
Hove, East Sussex BN3 1DD
UK
Tel: + 44-1273-7272-68
Fax: + 44-1273-7272-69

Distributed to the trade in the United States by:
Watson-Guptill Publications
1515 Broadway
New York, NY 10036

ISBN 2-88046-349-1

This book was designed, edited and produced by
Hilton & Stanley
63 Greenham Road
London N10 1LN
UK

Design by David Stanley
Illustrations by Brian Manning
Picture research by Anne-Marie Ehrlich

DTP in Great Britain by
Hilton & Stanley

Production and separation in Singapore by ProVision Pte. Ltd.
Tel: + 65-334-7720
Fax: + 65-334-7721

Photographic credits
Front cover: Donald Graham
Page 1: David Prior
Pages 2–3: Comstock/Tom Grill
Page 160: David Prior
Back cover: Comstock/Mike Stuckey

Contents

1

Aspects of close-ups

2

Focusing on people

3 Architecture in detail

4 The Natural World

5 Portfolio

Introduction

CREATIVE PHOTOGRAPHY IS OFTEN SHACKLED by the commonly held perception that the photographic image 'does not lie' – that it is, in fact, a mere representation, a mirror image, of the world we all see all around us all of the time. Nothing need be further from the truth.

The success or otherwise of any image has more to do with the perceptions of the photographer than any considerations of equipment, and this is especially true of close-up photography. For without the ability to see and then visually isolate that part of the subject or scene in front of the camera, no amount of specialized kit will be of much help.

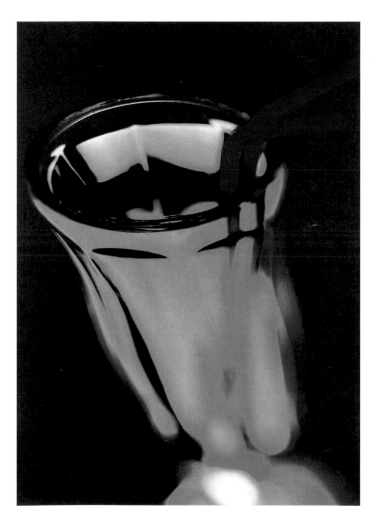

◀

Rather than being an end-product, close-up imagery such as this can be the starting point for a whole range of startling after-treatments.

Images within images

It is easy to fall into the way of thinking that close-up photography is not feasible because you don't have access to macro lenses, extension tubes or a bellows unit. For certain types of work, the ability to focus closely on extremely small subjects or very localized areas of larger subjects may require you to use such specialized equipment as this, but for the overwhelming majority of the close-up images presented in this book all you need is the ability to see the creative potential contained within a range of

PHOTOGRAPHER:
David Prior
CAMERA:
6 x 6cm
LENS:
150mm
FILM:
ISO 50
EXPOSURE:
⅟₆₀ second at f16
EFFECT:
False colour added by computer imaging

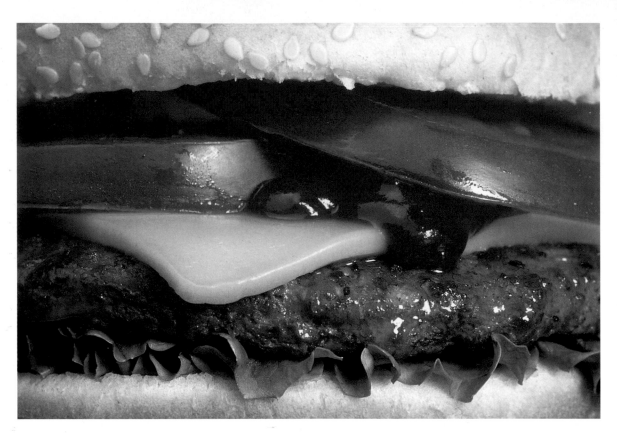

everyday subjects and situations. A field
of ripening grass seed, for example,
glanced at casually or photographed as
a broad landscape shot with a standard
of wide-angle lens, may appear to be of
a uniform colour. Look closer, however,
and you may see that contained within a
single seed head there is a gradation of
colour from green to gold. Look closer
still and, unexpectedly, there is a flush of
the most delicate pink within the seed
head's very heart.

Translating the image

At least as important as being able to
see the image you want to record is your
ability to translate that image on to a
strip of film. A close-up of a face, for ex-
ample, shot with a telephoto lens, may
have less impact than you envisioned
because the depth of field associated
with the aperture selected was too
extensive to isolate the subject from an

intrusive background. Rather than
achieving a photograph with a single,
clear focus for the viewer's attention,
you may have ended up with rather a
mundane snapshot of a subject and
setting competing for centre stage.

A technical problem more commonly
experienced by close-up photographers,
however, is a lack of depth of field. The
closer the focusing distance and the
longer the focal length of the lens, the
less depth of field there is in which to
contain your subject. If there is sufficient
light, existing or introduced, you can
select the smallest aperture available on
your lens, but this may result in you
having to set a compensating shutter
speed so slow that taking a hand-held
exposure is impossible if you are to
avoid camera shake. As with all areas of
photographic interest, in close-up
photography there is often a trade-off to
be made in order to satisfy competing
technical considerations.

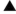

By shooting with a
telephoto lens, the
photographer has
filled the picture
area with a
detailed image of
food, lit to make it
look as appealing
as possible.

PHOTOGRAPHER:
**Comstock/Mike
Stuckey**
CAMERA:
6 x 4.5cm
LENS:
250mm
FILM:
ISO 50
EXPOSURE:
$1/25$ second at f22
LIGHTING:
**Studio flash x 2
(both fitted with
snoots)**

Previsualizing a close-up photograph means selecting from within the scene or subject the most relevant visual elements and then excluding all else from the frame. Here, the type of equipment available to most averagely equip-ped photographers has been used to extract a strong and an appealing image from a scene full of distracting clutter.

PHOTOGRAPHER:
Comstock/Mike & Carol Werner
CAMERA:
35mm
LENS:
90mm
FILM:
ISO 100
EXPOSURE:
1/60 second at f11
LIGHTING:
Daylight and accessory flash

Equipment and accessories

THERE IS NO ATTEMPT MADE IN THIS BOOK to limit the scope of close-up photography to the realms of the specialist. In fact, whether you own a 35mm camera – SLR preferably, but even a direct-vision compact camera does not rule you out – or one of the many medium format models, many aspects of close-up photography are immediately available to you, but a few pieces of extra equipment will immeasurably broaden your options.

Medium format cameras

The advantage most photographers see in using medium format cameras is that the large negative size – in relation to the 35mm format – produces excellent-quality prints or slides, especially when big enlargements are called for, and that this fact alone outweighs any other considerations. The larger size of the negative (or slide positive) becomes especially important if you want to create a close-up image by selectively enlarging only a part of the film original. The major disadvantages with this format are that, again in relation to the 35mm format, the cameras are heavy and slightly awkward to use; they are not highly automated (although this can often be a distinct advantage); they are expensive to buy; and you get fewer exposures per roll of film.

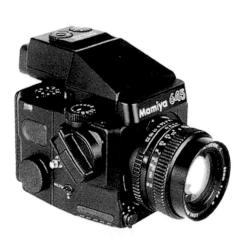

◄ This is the smallest of the medium format cameras available, producing rectangular negatives or slides measuring 6cm by 4.5cm.

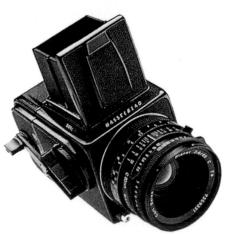

◄ This is probably the best known of all the different medium format cameras, producing square-shaped negatives or slides measuring 6cm by 6cm.

35mm single lens reflex (SLR) and compact cameras

The 35mm format is the best supported of all the formats, due largely to its popularity with amateur photographers. There are at least six major 35mm SLR manufacturers, each making an extensive range of camera bodies, lenses, flash

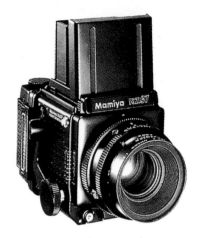

This is the largest of the popular medium format cameras, producing rectangular negatives or slides measuring 6cm by 7cm. (A 6cm x 9cm format is also available but is not commonly used.)

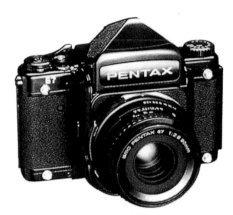

This type of 6cm x 7cm medium format camera looks like a scaled-up 35mm camera, and many photographers find the layout of its controls easier to use than the more box-like models.

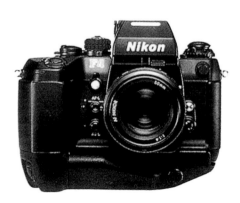

This top-quality professional 35mm camera, here fitted with a motor drive, features a die-cast body; a choice of metering systems, different viewing screens and finders; exposure lock and compensation; and a choice of aperture- or shutter-priority, fully automatic or manual exposure.

units and specialized – as well as more general – accessories. Cameras within each range include fully manual and fully automatic models. Lenses and accessories made by independent companies are also available. Compared with medium format cameras, 35mm SLRs are lightweight, easy to use, generally feature a high degree of automation and are extremely flexible working tools. For big enlargements, however, medium format cameras have a definite edge in terms of picture quality.

Compacts (also known as 'point-and-shoot' cameras) have a lens that cannot be removed and replaced with another of a different focal length. Also, the image of the subject you see in the viewfinder is not precisely that seen by the lens and so there is always the possibility of framing errors occurring, especially at close-focusing distances. However, some top-of-the-range models feature zoom lenses, taking you from moderate wide-angle to moderate telephoto and can, for example, be used for many of the types of close-up subject seen in this book. For very close-focusing work, lenses found on some compacts will accept close-up filters. These come in different dioptre strengths and allow the lens to focus much closer than normal. The huge disadvantage, however, is that the viewfinder cannot then be used to sight the camera accurately.

Lenses

When it comes to buying lenses for 35mm or medium format SLRs you should not compromise on quality. No matter how good the camera body is, a poor-quality lens will take a poor-quality picture, a fact that will become all too apparent when enlargements are

made, so always buy the very best you can afford.

One factor that adds to the cost of a lens is the widest maximum aperture it offers. Every time you change the aperture to the next smallest number – from f5.6 to f4, for example – you double the amount of light passing through the lens, which means you can shoot in progressively lower light levels without having to resort to flash. At very wide apertures, however, the lens needs a high degree of optical precision to produce images with minimal distortion, especially toward the edges of the frame. Thus, lenses offering an aperture of f1.4 cost much more than lenses with a maximum aperture of f2.8. Another advantage of using a wide-aperture lens is that the extra light it transmits produces a brighter viewfinder image – and the brighter the viewfinder image the easier it is to focus, and accurate focusing is critically important with many types of close-up subjects.

As an alternative to carrying around a range of fixed focal length prime lenses, you could consider using a combination of different zoom lenses. For example, you could (for the 35mm format) have a 28–70mm zoom, another covering the range 70–210mm. A feature commonly available on modern zoom lenses is 'macro mode'. At this setting, the lens

focuses much closer than its focusing range would normally allow, but this focusing distance is fixed and you cannot then zoom the lens to vary the image size of the subject.

For those photographers with a specialist interest in close-ups, then dedicated 'macro lenses' are available. These lenses are made in a limited range of focal lengths but they are designed to produce their best results at extremely close focusing distances. They are, however, expensive to buy and have only limited applications for non-close-up photography.

Ring flash

One of the problems with extreme close-up work is that the camera and lens may be so close to the subject that any available light simply cannot get through. Even if it can, some close-up subjects demand completely even lighting, since any shadows may be a source of confusion. In this situation, the best form of artificial lighting to use is ring flash (below left). Consisting of a circular flash tube that fits around the front of your lens, ring flash is synchro-nized to the shutter release by a cable (obviously, the flash cannot be seated in the camera's hot shoe) and produces completely shadowless lighting.

Studio flash

For the studio-based non-specialist photographer, the most widely used light source is studio flash. Working either directly from the mains or via a high-voltage power pack, recycling time is virtually instantaneous and there is no upper limit on the number of flashes.

A range of different lighting heads, filters and attachments can be used to

▼

The circular flash tube of a ring flash fits around the front of the lens. This is attached via a cable to the control unit, which slips into the camera's hot shoe, and governs synchronization.

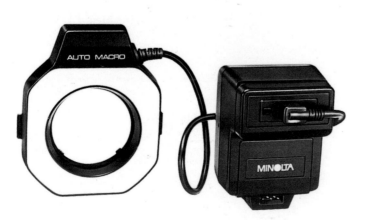

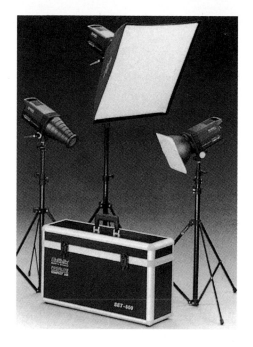

▲

This type of lightweight set-up will give you professional as well as flexible lighting in the studio or out on location.

Bellows and extension tubes

Look at the barrel of the lens as you focus and you will see that it extends to accommodate close focusing distances. Users of SLRs can increase this extension considerably by fitting a bellows unit between the camera body and lens. Using the focusing rail provided either to compress or extend the bellows, you have the option of varying the degree of magnification to produce life-sized or larger images.

Extension tubes perform the same function as bellows. Available in sets, they can be used in combination between the camera body and lens to produced stepped degrees of subject magnification. Extension tubes are cheaper to buy but because they don't allow continuously variable magnification they are not as flexible as bellows.

If you buy bellows tubes from the manufacturer of your camera, or from an independent manufacturer making equipment specifically to be used with your model, you should retain full TTL (through-the-lens) metering and automatic diaphragm control.

create virtually any lighting style or effect, and the colour temperature of the flash output matches that of daylight, so the two can be mixed in the same shot without any colour casts.

When multiple lighting heads are in use, as long as one light is linked to the camera, synchronization cables can be eliminated by using slave units with the other heads. Another advantage of flash is that it produces virtually no heat, which can be a significant problem when using studio tungsten lighting. To overcome the problem of predicting precisely where subject shadows and highlights will occur, which cannot be seen normally because the burst of light from the flash is so brief, each flash head should be fitted with a 'modelling light'. The output from these lights is low and won't affect exposure, but it is sufficient for you to see the overall effect with a good degree of accuracy.

◄

Extension tubes can be used in combination to give stepped degrees of image magnification.

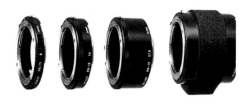

◄

The flexible connector, or bellows, can be adjusted to give continuous degrees of image magnification.

1

ASPECTS OF CLOSE-UPS

Isolating colour

Areas of colour in a scene that, in a broadly framed photograph, may be small and insignificant can take on a dominant role in a close-up picture. It may be that, once isolated from its surroundings, a colour can be seen to contrast with its immediate neighbour with a pulsing and compelling intensity. Alternatively, soft and muted colours may emerge once stronger hues are eliminated from the frame.

When viewing a scene with your unaided eye you may find it difficult to omit mentally potentially unwanted and competing subject elements that present themselves in the varying subject planes. If so, one technique sometimes used by artists to help sharpen their mental focus, and to allow them to concentrate on just small areas of a landscape or other scene at a time, is to look through two L-shaped pieces of cardboard held at arms' length in front of them. Move the two shapes closer together or further apart to form a square or rectangle that roughly corresponds to the shape of your camera's picture format. More directly than this, you can always view a scene through your camera's viewfinder with your free eye firmly shut. Change lenses or focal length settings on a zoom lens as necessary, look up or down, left or right and let the world come to you solely via the hard-edged boundaries of the viewing screen. But remember to look closely at the entire screen – all it takes is a slight lapse in concentration and you may fail to notice some unwanted subject element creeping in at the edge of the frame until you are holding the processed film in your hand.

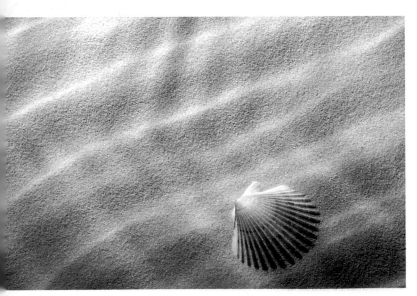

With no others colours to compete, the pink of this shell becomes the focal point of the composition. From the view that has been presented here, you can see how the photographer's imagination has created an image out of nothing.

Photographer:
Comstock/Mike Stuckey
Camera:
35mm
Lens:
50mm
Film:
ISO 64
Exposure:
1/25 second at f22
Lighting:
Daylight only

PHOTOGRAPHER:
Bert Wiklund
CAMERA:
35mm
LENS:
55mm macro
FILM:
ISO 50
EXPOSURE:
**⅟₆₀ second
at f8**
LIGHTING:
Daylight only

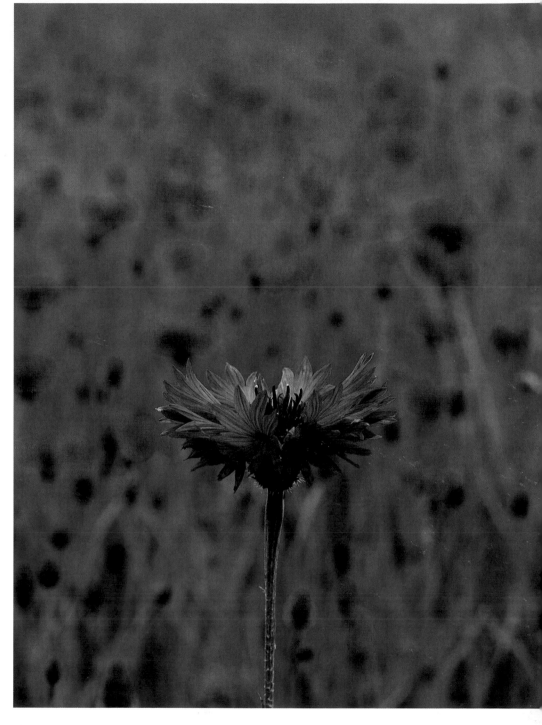

▲

The intense blue of this cornflower bloom has been intensified by
the photographer's use of the close-focusing facility of a
specialized macro lens. Note the strongly three-dimensional effect
created by the deeper colour of the more shadowed parts of the
bloom closest to the camera position, contrasting with those parts
that are in full sun.

Camera viewpoint, focal length and exposure are the three principal ingredients of this very selective close-up view. A slightly low camera angle helped to exclude the clutter of assorted street and shop signs that surrounded this one element the photographer wanted to concentrate on. Likewise, the focal length of the lens also helped to determine what was recorded and what was omitted. The colour impact of this simple image is telling, and this component the photographer manipulated by underexposing the scene by about ½ a stop, which, when using slide film, can make colours appear stronger, more intense and fully saturated.

PHOTOGRAPHER:
Comstock/Tom Grill
CAMERA:
6 x 4.5cm
LENS:
80mm
FILM:
ISO 50
EXPOSURE:
$\frac{1}{250}$ second at f8
LIGHTING:
Daylight only

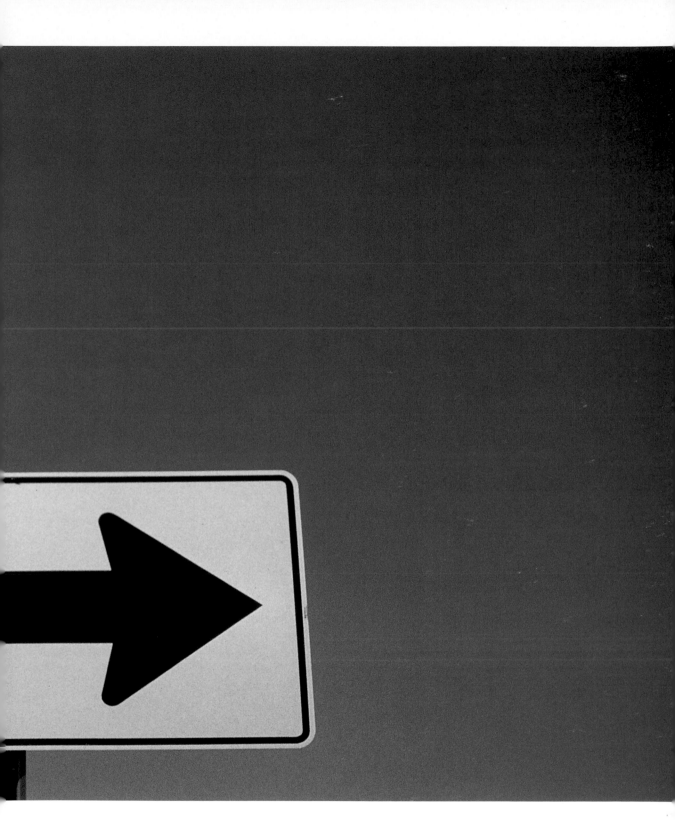

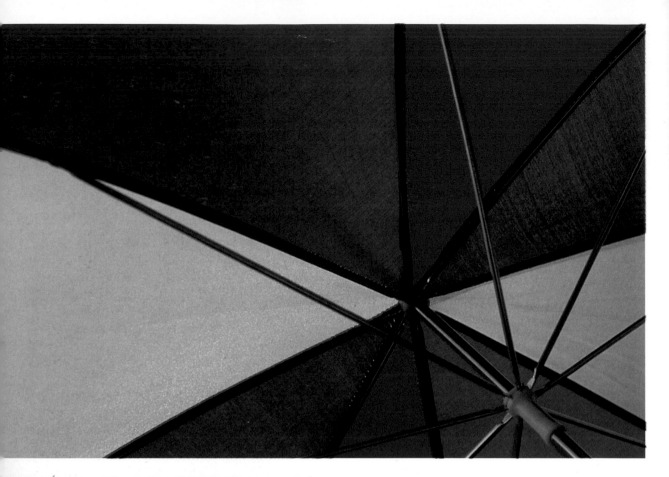

▲

Here the photographer has seen a chance to make a strong colour statement and has zoomed in close to fill the picture area with the vivid contrasts of the primary-coloured segments of a beach umbrella positioned in full sunshine.

◄

A display of fruit and vegetables outside a greengrocer's store can be an opportunity to create a multicoloured composition or, as here, a predominantly single-coloured image by selectively framing just a small portion of the overall scene.

PHOTOGRAPHER:
Comstock/Bob Pizaro
CAMERA:
35mm
LENS:
70–210mm zoom (set to 170mm)
FILM:
ISO 100
EXPOSURE:
½₅₀ second at f8
LIGHTING:
Daylight only

PHOTOGRAPHER:
Comstock/ George Lepp
CAMERA:
35mm
LENS:
135mm

FILM:
ISO 64
EXPOSURE:
¹⁄₆₀ second at f16
LIGHTING:
Daylight only

A trick of the light
has transformed
this gloriously
honey-coloured
piece of wood, its
undulating surface
taking on the
fluidity of a length
of fabric moving
gently in response
to a warm,
summer breeze.

PHOTOGRAPHER:
Comstock/Tom Grill
CAMERA:
35mm
LENS:
90mm
FILM:
ISO 100
EXPOSURE:
1/60 second at f8
LIGHTING:
Daylight only

Seeing shape

CAREFUL OBSERVATION OF YOUR SURROUNDINGS is the first step in helping you to see the potential of a particular feature, such as shape, and to make it the subject, rather than just a part of, a photograph. In 'normal' vision, shape is one of the key ways we have of identifying familiar objects and people. Often, a person seen at a distance can be recognized long before any facial features become apparent, simply because we instinctively recognize that person's outline and carriage. With close-up subjects, however, shape takes on a new meaning. Stripping away the wider view often removes much of the familiarity, and so shape used as the subject of a close-up photograph may often take on more of an abstract quality.

Different qualities of lighting have a very direct effect on out perception of shape. Often, it is an uncompromising type of lighting – where subject elements or planes of the same subject element are either lit or unlit – that conveys the most pronounced impression of shape. Softer, diffused or reflected lighting tends to produce a greater range of tonal gradations or variations in hue than direct lighting, which helps to emphasize form. For shape to work as the principal subject of a photograph, it does not necessarily have to convey three-dimensionality, so initially keep your lighting arrangement simple or, when working outdoors in natural light, adjust your camera position until you see the image in the viewfinder that best expresses your vision of the subject.

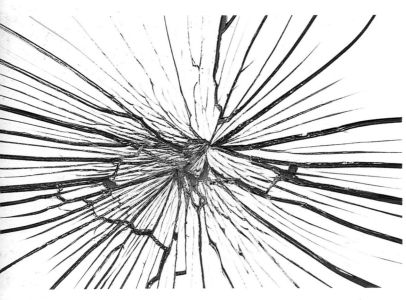

◄

What could be easier to overlook that this – a powerful series of shapes made by a randomly cracked pane of glass? Seen close up, the radiating shapes of fracture lines take on the appearance of a web or some vast geological feature viewed from high above the ground.

PHOTOGRAPHER:
Comstock/Bob Pizaro
CAMERA:
35mm
LENS:
105mm
FILM:
ISO 200
EXPOSURE:
½₅₀ second at f8
LIGHTING:
Daylight only

Shape and repetition are the main features of this shot of intermeshing clockwork gear wheels. Seen in isolation from the remainder of the mechanism, the eye automatically starts to explore the repeating shapes of teeth, wheels, hubs and spokes. Computer manipulation of the original image accounts for the false-colour highlights and shadows.

PHOTOGRAPHER:
Comstock/Mike Stuckey
CAMERA:
6 x 4.5cm
LENS:
80mm (plus extension bellows)
FILM:
ISO 200
EXPOSURE:
⅟₆₀ second at f16
LIGHTING:
Studio flash

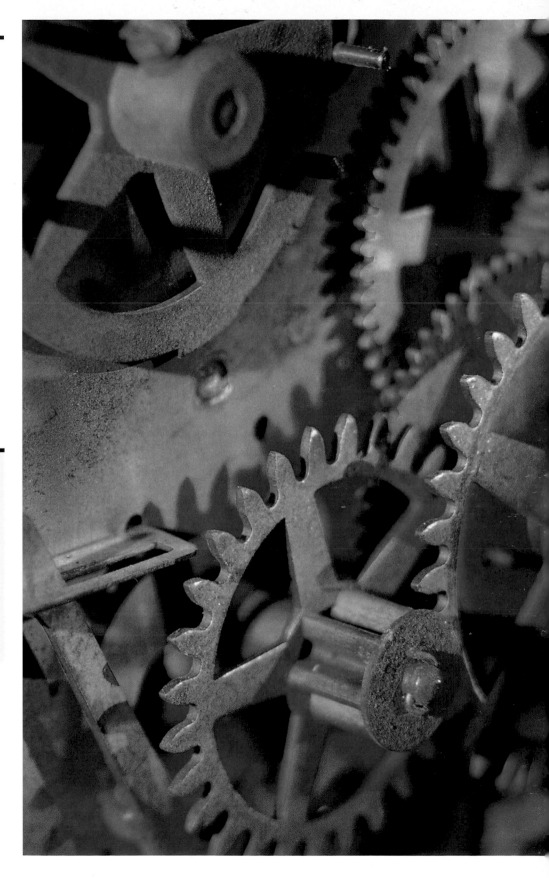

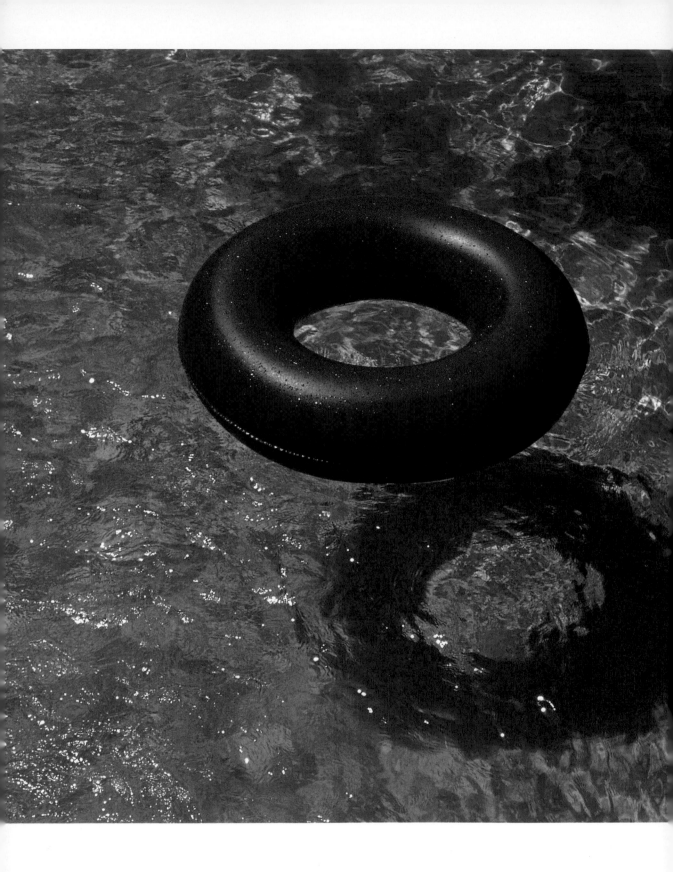

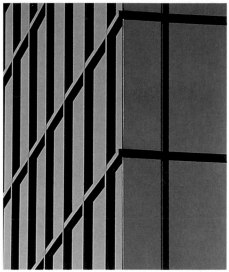

◄ ▲

Direct, intense sunlight has given us this image in which shape is the subject. The simplicity of the shape of the rubber ring is intriguing, and the photographer has exploited this further by showing us a stark contrast of red against blue.

The regularly black-outlined window frames making up this façade have been isolated by the narrow angle of view of a long lens. Through this device, a geometric abstract has emerged from an otherwise prosaic subject.

PHOTOGRAPHER:
Comstock/Mike Stuckey
CAMERA:
6 x 7cm
LENS:
90mm
FILM:
ISO 64
EXPOSURE:
½₅₀ second at f16
LIGHTING:
Daylight only

PHOTOGRAPHER:
Comstock/Bob Pizaro
CAMERA:
35mm
LENS:
250mm
FILM:
ISO 50
EXPOSURE:
½₅₀ second at f11
LIGHTING:
Daylight only

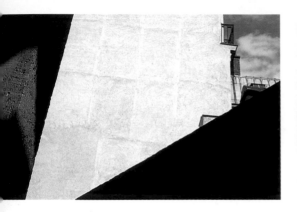

▲ ►

Modern architecture, relying as it often does on geometric form, offers many opportunities for those looking for examples of shape in buildings and strucures. Here, the photographer has used the angular opening in the wall of a car-park to emphasize the starkness of much of the modern built environment.

Recorded largely by transmitted rather than reflected light, shape is the dominant feature here. The limited depth of field available meant that the two foreground leaves had to be positioned in nearly the same plane in order to show them both clearly and sharp-edged.

PHOTOGRAPHER:
Paul Kirk
CAMERA:
35mm
LENS:
50mm
FILM:
ISO 64
EXPOSURE:
$\frac{1}{125}$ second at f8
LIGHTING:
Daylight only

PHOTOGRAPHER:
Comstock/
Mike Stuckey
CAMERA:
6 x 4.5cm
LENS:
80mm (plus extension tube)
FILM:
ISO 50
EXPOSURE:
$\frac{1}{15}$ second at f22
LIGHTING:
Daylight only

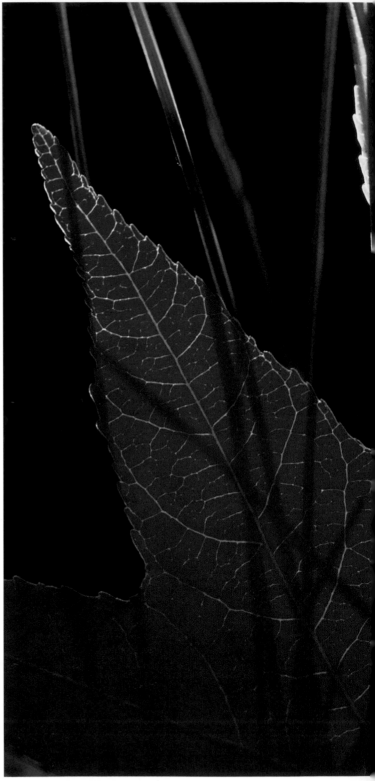

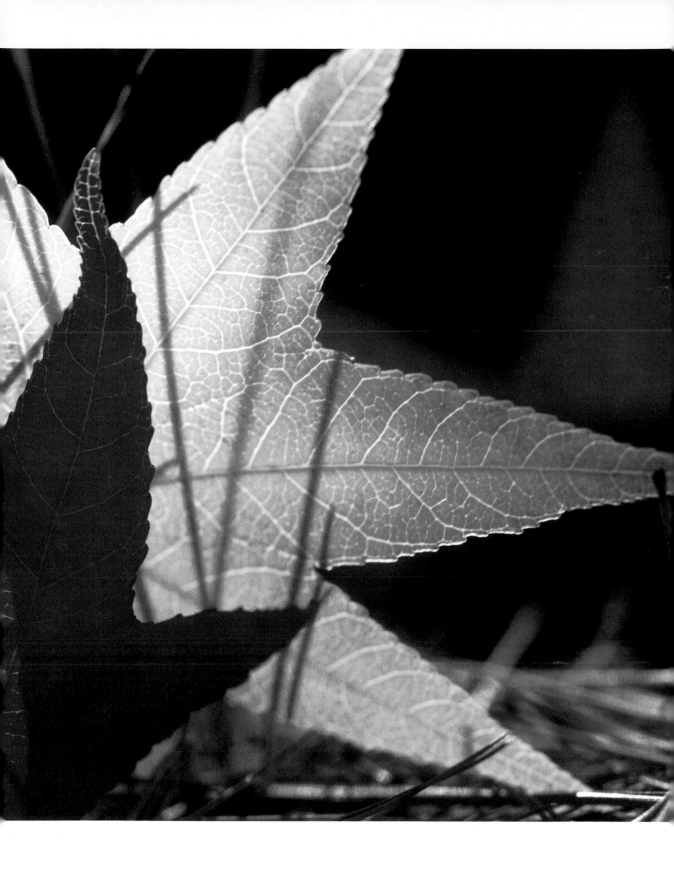

Seeing form

BECAUSE CLOSE-UPS SO OFTEN CONCENTRATE the viewer's attention on aspects of the subject that have little to do with simple recognition, such subject characteristics as form become more important. Of all the obvious subject characteristics – shape, colour, texture and pattern, for example – it is form that is the hardest to describe, for it is form that gives the impression of depth, roundness, solidity and a sense of what it might be like to hold or touch the subject in what is a flat and two-dimensional print or projected slide image.

As with all aspects of photography, it is light that defines the subject, and with form it is the interplay of light and shade that is the crucial factor. Frame-filling subjects that are evenly sharp and uniformly lit throughout, with few, if any, gradations of tone or hue, often take on the flattest appearance. Likewise, a subject that is underlit, with all surfaces uniformly dark, also has a two-dimensional quality, which, in the example of a silhouette, can give the impression of being a cut-out. To record the most pronounced sense of subject form, concentrate the camera wherever you see tones and hues grading or sharply varying in response to the direction of the available illumination.

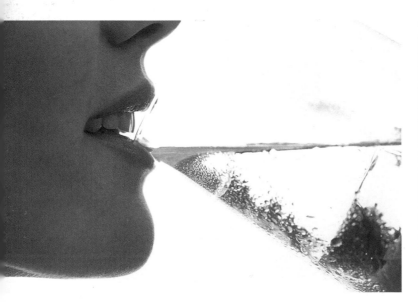

Even and heavily diffused lighting has been used to illuminate this close-up. The different planes of the woman's face show little grad-ation of colour or tone, and the glass she is drinking from has no catchlights and also appears two-dimensional. The only place where the image appears rounded is where a glint of light reflects from the subject's teeth.

PHOTOGRAPHER:
Comstock/Tom Grill
CAMERA:
6 x 7cm
LENS:
150mm
FILM:
ISO 100
EXPOSURE:
1/60 second at f8
LIGHTING:
Studio flash fitted with softbox

AN EXERCISE IN FORM

To see the effects that the direction and quality of light have on form in the most dramatic way, place a simple object, such as an apple, in a clear, open space. Then, using a lightweight desk lamp alone (turn off or subdue all other room lighting), move it in a series of arcs above and around the apple from side to side and back to front and note how the roundness of the piece of fruit (or any other subject you are using) and its tangible qualities vary depending on where the light falls on it. For a different effect, stick a disc of heavy tracing paper over the front of the lamp, so that the light output is diffused, and try this lighting exercise again.

▶

PHOTOGRAPHER:
Comstock/Mike Stuckey
CAMERA:
6 x 4.5cm
LENS:
105mm (plus extension tube)
FILM:
ISO 50
EXPOSURE:
⅟₆₀ second at f16
LIGHTING:
Overhead flash

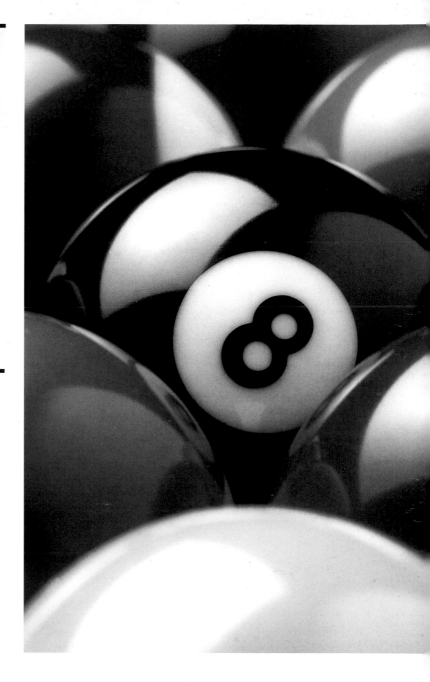

This close-up of bunched-up pool balls clearly demonstrates the importance of catchlights in helping to define the form of shiny, highly reflective objects. To see the difference, simply cover up the reflection of the overhead light in any one of the balls and you will see how at once its appearance changes.

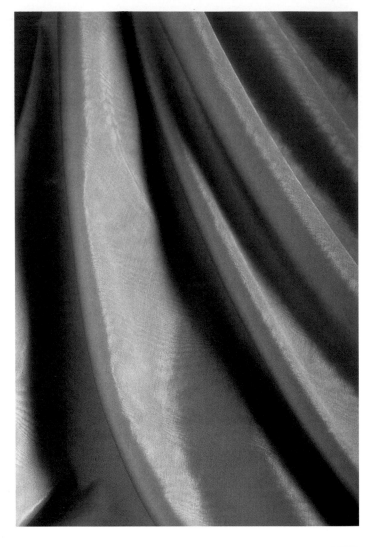

With heavily draped material you need to take care that your lighting set-up does not produce so much contrast that both the highlights and the shadows cannot be comfortably accommodated at the same exposure setting. In this example, a studio flash unit was set up to the right of the camera position so that its light reached the material at an angle of about 45°. This light alone would have brightly illuminated all the planes facing the flash head and cast deep on to the reverse planes and into the hollows. To overcome this potential problem, the photographer positioned a large white-painted studio flat on the opposite side of the subject, angled to catch any light spilling past and to reflect it back.

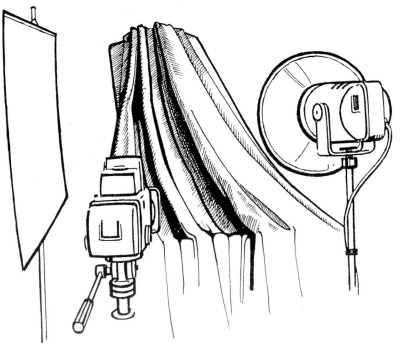

PHOTOGRAPHER:
Comstock/Mike Stuckey
CAMERA:
35mm
LENS:
105mm
FILM:
ISO 64
EXPOSURE:
1/60 second at f22
LIGHTING:
Studio flash and reflector

These two subjects, although very different in what they portray, are extremely similar in character. In the shot of one face of a wind-sculptured dune, the photographer has been careful to frame the image so that it is difficult to see the scale of the undulating features. Are the valleys inches deep and taken from close to, for example, or feet deep and taken from much further back? Note that, just as with the shot of draped material opposite, you obtain the strongest sensation of the depth and roundness from the areas of the pictures where the highlights start to merge with the shadows and colours begin to change in intensity from light to dark, or from dark to light. It is in these areas that the 'feel' of the subject is most pronounced and the sense of the three-dimensional nature of the subject best communicated.

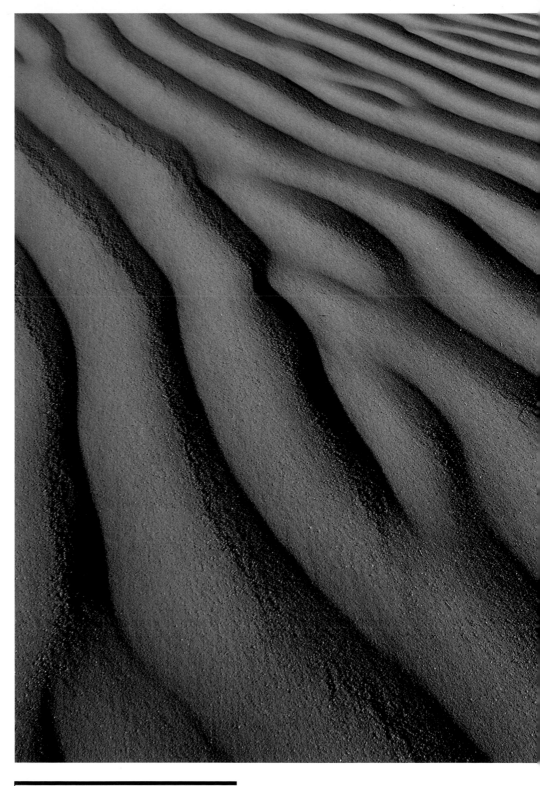

PHOTOGRAPHER:	FILM:
Comstock/Tom Grill	ISO 100
CAMERA:	EXPOSURE:
6 x 7cm	$\frac{1}{500}$ second at f11
LENS:	LIGHTING:
90mm	Daylight only

PHOTOGRAPHER:
Comstock/Phiz Mezey
CAMERA:
6 x 4.5cm
LENS:
250mm
FILM:
ISO 100
EXPOSURE:
1/30 second at f5.6
LIGHTING:
Overhead flash

▶

Lighting arranged above and slightly to the right of the camera position helps to accentuate the roundness of these ranked apples. To assist the lighting effect, and to emphasize the crisp freshness of the fruit, the photographer used a plant sprayer to coat their skins with fine droplets of water. Each droplet then becomes a potential focus to catch the light and create a random scattering of tiny highlights. The focus was set precisely for the single green apple, and an aperture was selected that showed the others slightly less than sharp.

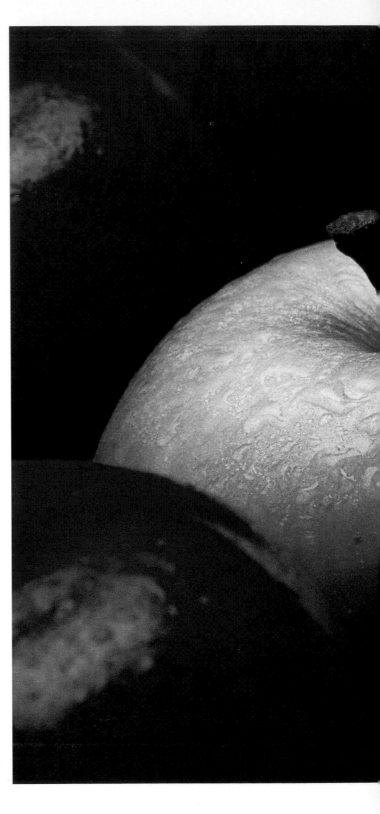

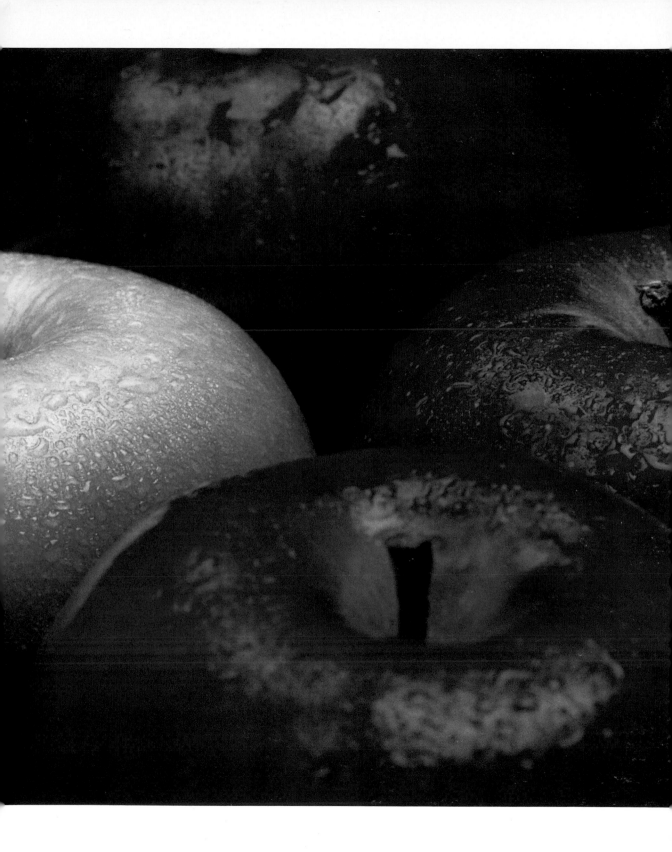

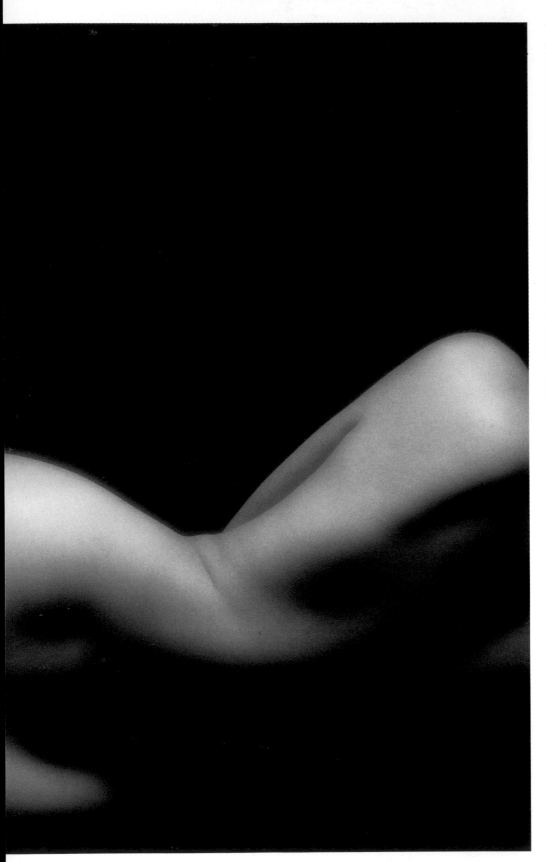

The human body when seen in close-up like this takes on a sculptural, semi-abstract quality, especially when the lighting has been arranged to emphasize the contours and curves of the subject. In common with the other images in this section, look at the parts of the subject where adjacent planes are seen to have received different intensities of light – the shoulder blades, spine, buttocks and the dip formed by the subject's arm and side – for it is here that form is most strongly defined.

PHOTOGRAPHER:
Comstock/Tom Grill
CAMERA:
6 x 4.5cm
LENS:
105mm
FILM:
ISO 50
EXPOSURE:
$\frac{1}{125}$ second at f11
LIGHTING:
Overhead flash

Seeing pattern

IN BOTH THE NATURAL WORLD and in the built environment, pattern surrounds us all of the time. Patterns are simply the repetitions of shapes, lines, colours, tones or textures arranged in such as way that they can be perceived as a design of some description. Although the wider environment is rich in patterns of all types, looking closely at the detail reveals an even greater wealth of potential interest for the close-up photographer.

A forest of trees, for example, can exhibit strong pattern in the repeating shapes of their linear tree trunks. Moving in closer, just one of those trees could become the subject of a photograph because of the pattern of markings, undulations or colour variations seen on its trunk. Look upwards and note the finger-like patterns bare branches make in winter after the tree has shed its foliage, or, alternatively, the pattern the branches form when they are heavily clothed in leaves and how, sometimes, these rounded heads of foliage echo the pattern of clouds in the sky. But take a close look at just one of those leaves and see the pattern of serrations or lobes on its periphery; and closer still there is yet another entire landscape to be discovered in the patterns of veins radiating outward from the main river-like artery running down its centre.

Because it is so easy to spoil a close-up image by failing to notice even the smallest detail that may distract from a picture's essential message, you need to ensure that you use camera-to-subject distance (if you are working with fixed-focus extension tubes, for example) or the variable-focus facility on a specialized close-up, or macro, lens to include only those elements that make a positive contribution to the overall composition.

PHOTOGRAPHER:
**Comstock/Mike
Stuckey**
CAMERA:
35mm
LENS:
85mm
FILM:
ISO 64
EXPOSURE:
**⅟₆₀ second
at f5.6**
LIGHTING:
Daylight only

▼

Wait for even,
subdued lighting
in order to see the
pattern in stained
glass to its best
advantage.

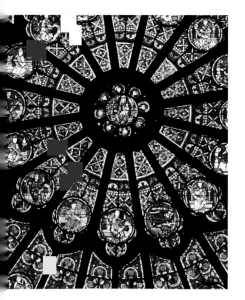

PATTERN AND PICTURE FORMAT

In general, patterns that radiate outward from a coherent point often make the most pleasing image when taken on a square-format camera, or on a rectangular image cropped square. Cameras, such as 35mm and most of the medium formats, produce rectangular images and this shape is most suitable for more linear designs and arrangements of subject elements. Although these cameras are easier to use when held horizontally, take the time to turn the camera through 90° to see if this change strengthens the appearance of pattern within the viewfinder frame.

▶

Glanced at quickly, this photograph could simply be showing a pattern of shapes making up a chain-link fence. However, by shooting from below and twisting the camera to make each sky-reflecting, glass-filled aperture distort into a diamond, the photographer has turned the bland face of an office block into an intriguing abstract. To ensure the illusion is maintained, it was important to use a small aperture to maximize depth of field and produce a consistently sharp image.

PHOTOGRAPHER:
Comstock/Mike Stuckey
CAMERA:
6 x 7cm
LENS:
80mm
FILM:
ISO 100
EXPOSURE:
1⁄₆₀ second at f22
LIGHTING:
Daylight only

▲

The random pattern of colour variations in
this close-up photograph of a flooring-
block of polished marble seems to become
more coherent the longer you look at it.
Perhaps this proves that we search for
order in what we observe, and we quickly
start to organize the swiggles, swirls and
blotches of orange and black into
repeating patterns.

PHOTOGRAPHER:
**Comstock/Mike
Stuckey**
CAMERA:
35mm
LENS:
135mm
FILM:
ISO 64
EXPOSURE:
1/60 second at f8
LIGHTING:
Daylight only

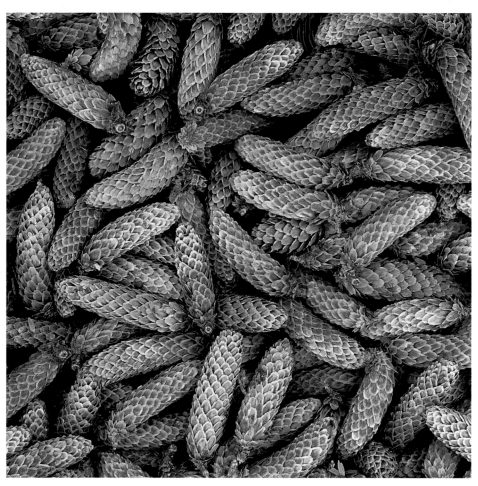

▲

Tightly cropped and filling the frame from edge to edge, this image of young, closely packed pine cones, still green before they harden, has been transformed into a pattern of curvaceous forms. And contained within each cone are yet further patterns – created by the overlapping shapes of the scales making up the surface of each one.

PHOTOGRAPHER:
Bert Wiklund
CAMERA:
6 x 4.5cm
LENS:
80mm
FILM:
ISO 100
EXPOSURE:
⅟₃₀ second at f22
LIGHTING:
Daylight only

The stormy blue
reflected in the
water's surface
makes the perfect
backdrop for this
short-lived and
ever-changing
pattern of radiat-
ing ripples.
Although it is
important to use
your powers of
observation and
judgement about
when to trip the
shutter, results will
always be hit and
miss, so it is best
to make two or
three exposures
and choose the
best afterwards.
To ensure that
each band of
ripples records as
a sharp-edged and
well-defined shape,
shutter speed may
be more important
than aperture.

PHOTOGRAPHER:
**Comstock/Mike
Stuckey**
CAMERA:
6 x 7cm
LENS:
150mm
FILM:
ISO 50
EXPOSURE:
**½₅₀ second
at f5.6**
LIGHTING:
Daylight only

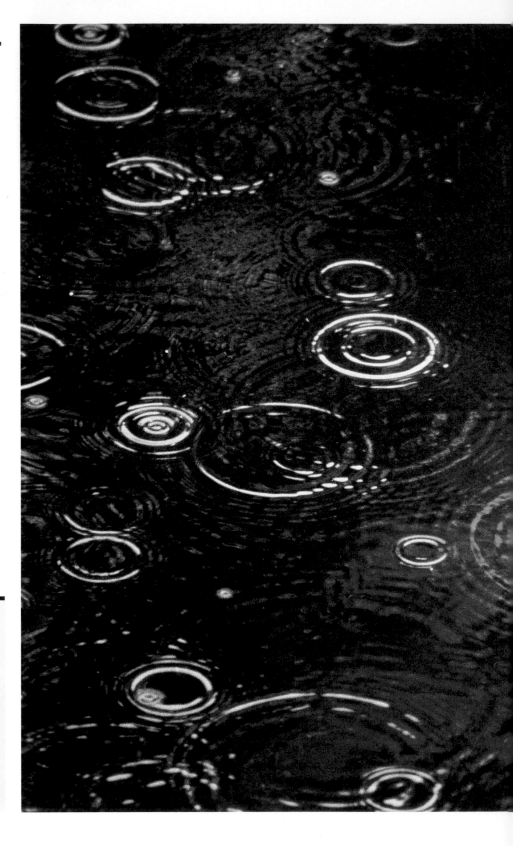

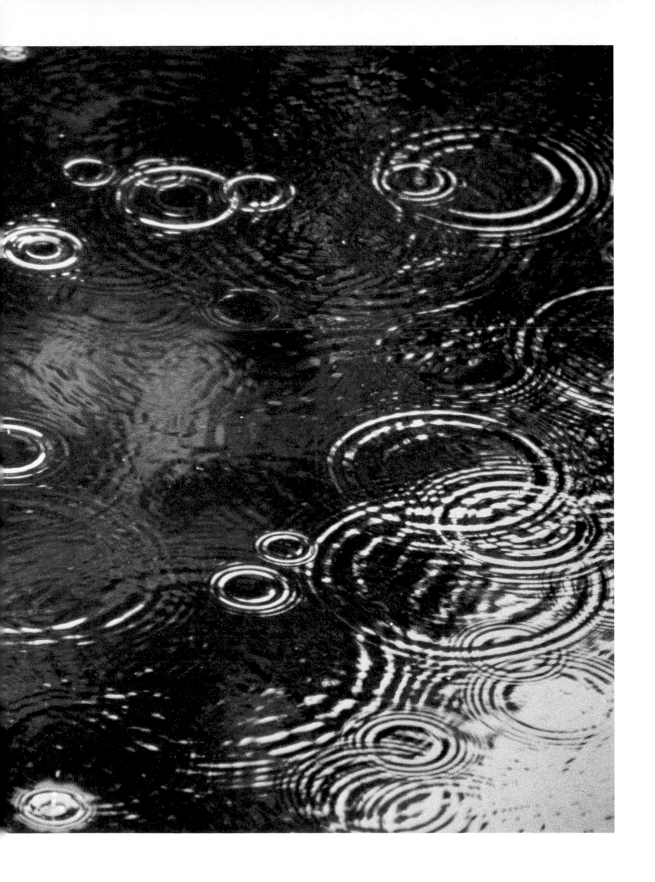

Creating impact

POINT THE CAMERA AT ANY GENERAL SCENE – a landscape, cityscape, a crowded street scene or quiet country lane – and the resulting image is likely to contain myriad different and, often, competing subject elements. So many, in fact, that it is sometimes hard to remember what the original point of the photograph was at the time of shooting. A picture such as this contains no obvious structure, has no focus for the viewer's attention and so lacks impact.

The essential difference between looking at a scene normally with your eyes and the way a scene is recorded by a camera is that when you look at a scene you selectively see only certain elements. It may be that a particular colour combination attracts your attention, or perhaps it is the shape made by the outline of a tree, an edge of a boulder against the sky, the pattern of window frames on the flat façade of a building or the texture and pattern you can discern on a simple strip of bark. A camera lens, however, is a neutral observer and whatever is in its field of view is recorded – the good, the bad and the simply indifferent.

One effective way of producing a photograph that more closely corresponds to the image in your mind's eye, is to move in as close as you can to encapsulate the essential subject elements and use the boundaries of the viewfinder to crop out anything in the scene that weakens your composition's essential message. Moving in close, of course, does not necessarily mean changing your camera position – changing to a longer lens, or using a longer zoom setting, may be a better option in many situations. Either way, you are likely, through a process of simplifying the image, to create one with more presence and greater impact.

▶

Photographed in Tunisia, this picture is, technically, an acceptable double portrait. The photographer has positioned the subjects well in the intense sunlight, so that the shadows falling on the their faces help to define form without being so dense that detail is lost. However, the essentially central framing in a slightly distracting background is a little prosaic and your eye, as you view the image, tends to flit from face to face, searching largely unsuccessfully for a point to concentrate on.

PHOTOGRAPHER:
Bert Wiklund
CAMERA:
35mm
LENS:
70–210mm zoom (set at 70mm)
FILM:
ISO 100
EXPOSURE:
$\frac{1}{500}$ second at f5.6
LIGHTING:
Daylight only

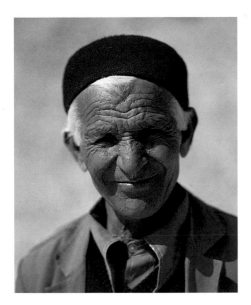

▲

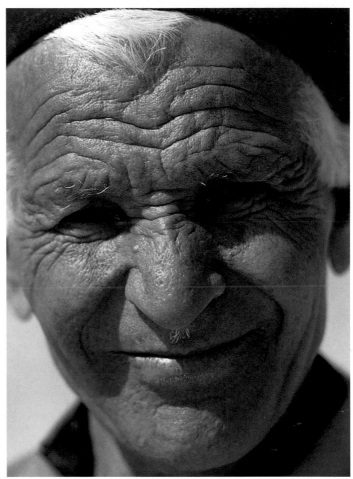

▲

Standing in the same camera position that he used for the first image (left), here the photographer has zoomed in to simplify the image and concentrate on just one of the figures. This instantly enlivens the composition and produces a picture that seems to invite our attention. Note, too, how using the telephoto end of the zoom lens has rendered the background as an unreadable, even-toned and unobtrusive blur.

PHOTOGRAPHER:
Bert Wiklund
CAMERA:
35mm
LENS:
70–210mm zoom (set at 210mm)
FILM:
ISO 100
EXPOSURE:
1/500 second at f8
LIGHTING:
Daylight only

This image is a detail of the previous photograph. Selectively enlarged in the darkroom, the photographer has now presented us with an image with real impact, one in which every deeply etched line and wrinkle – the contour lines of the man's life – can be explored. By omitting all extraneous subject elements and reducing the picture's content to the bare minimum, we seem to be able to read the subject's history and character. And note how the almost jarring contrast of the man's wisp of white hair seen against a rim of red fez lifts the entire content of the photograph.

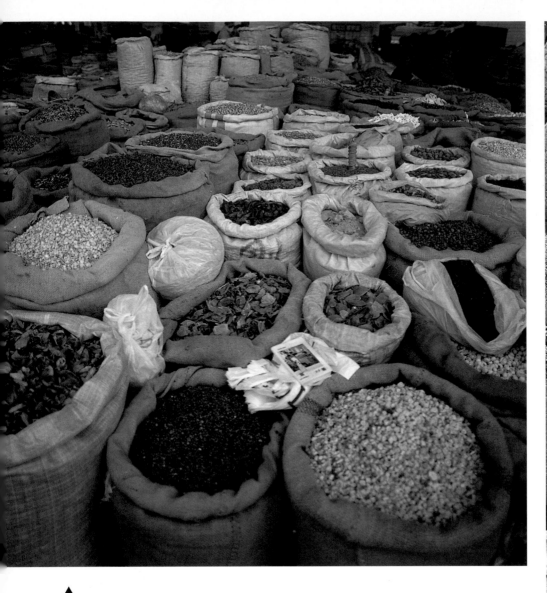

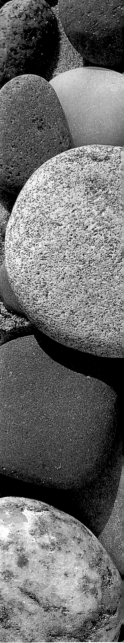

Wide-angle lens are often associated with broad landscape images showing skies that seem to stretch up and over the camera position. Use them close to the subject, however, and an entirely different application for this type of optic becomes apparent. Because of their extensive angle of view, you need to check the corners and edges of the viewfinder carefully before making an exposure to ensure that no extraneous subject matter has crept into the picture area. The depths of field associated with all apertures of a wide-angle can also work to your advantage if you want subject elements at all distances from the camera to have the same clarity.

PHOTOGRAPHER:
Bert Wiklund
CAMERA:
35mm
LENS:
28mm
FILM:
ISO 50
EXPOSURE:
⅟₆₀ second at f11
LIGHTING:
Natural window light

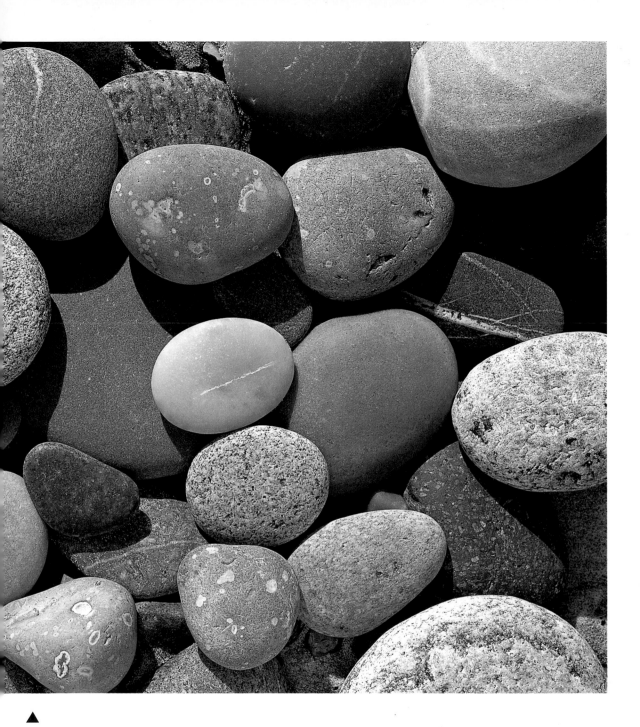

▲

The art of photography has little to do with equipment and technique and everything to do with 'seeing'. A random collection of coloured, water-worn pebbles on a beach can be transformed into an eye-catching photograph if only you can develop the ability to see – rather than just look.

PHOTOGRAPHER:	EXPOSURE:
Bert Wiklund	**½₅₀ second**
CAMERA:	**at f11**
6 x 4.5cm	LIGHTING:
LENS:	**Daylight only**
80mm	
FILM:	
ISO 100	

Closing in on this collection of decorative tourist pottery – typical of many countries in and around the Mediterranean – allows you the time to see the repetition of pattern, shape and colour that could easily pass unnoticed in a wider-framed shot, which might be showing these same plates and bowls as just an element of a busy street scene.

PHOTOGRAPHER:
Bert Wiklund
CAMERA:
6 x 4.5cm
LENS:
180mm
FILM:
ISO 100
EXPOSURE:
1/125 second at f8
LIGHTING:
Daylight only

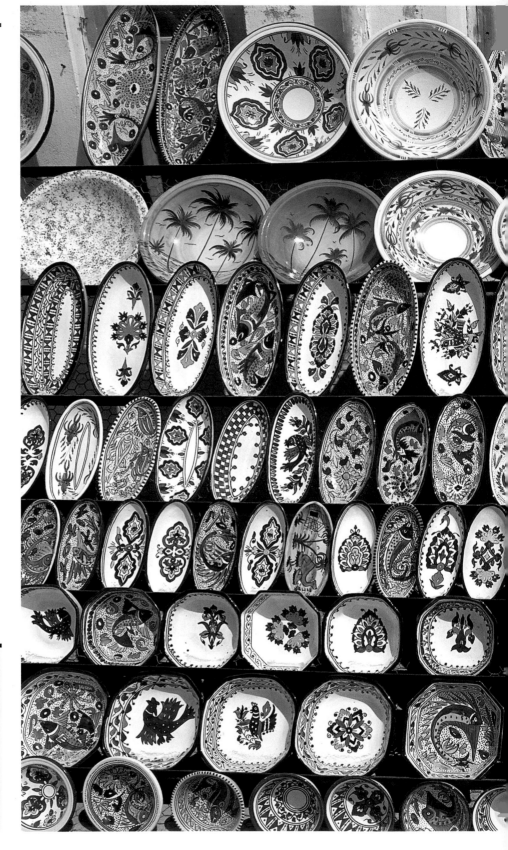

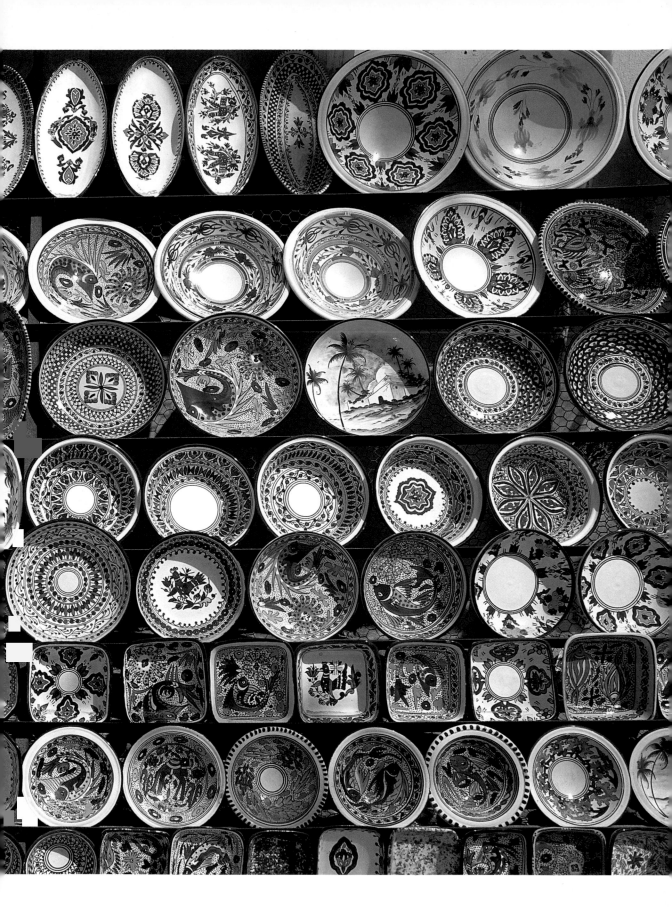

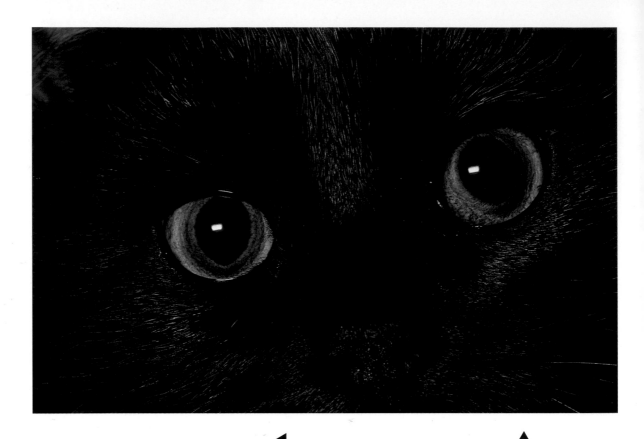

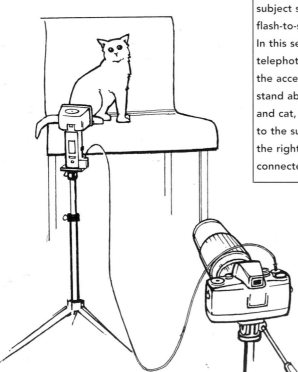

◄ The light output of a camera-mounted flash may be inadequate to illuminate a subject shot with a long lens, because the flash-to-subject distance may be too great. In this set-up, the 35mm camera and telephoto lens were tripod mounted and the accessory flash was fixed to a lighting stand about half-way between the camera and cat, and positioned almost square on to the subject. To ensure the flash fired at the right time, a long synch cable connected the flash and camera.

▲ For real picture impact, it is hard to beat this approach. Working with animals, you cannot come physically too close to your subject because it is likely either to bolt or investigate the front of your lens with its nose. The best approach, therefore, is to stand at the closest minimum focusing distance of a telephoto lens and use its magnifying power and narrow angle of view to achieve a selective view of the subject.

PHOTOGRAPHER:
Bert Wiklund
CAMERA:
35mm
LENS:
70–210mm zoom (set at 210mm)
FILM:
ISO 50
EXPOSURE:
⅟₆₀ second at f8
LIGHTING:
Accessory flash

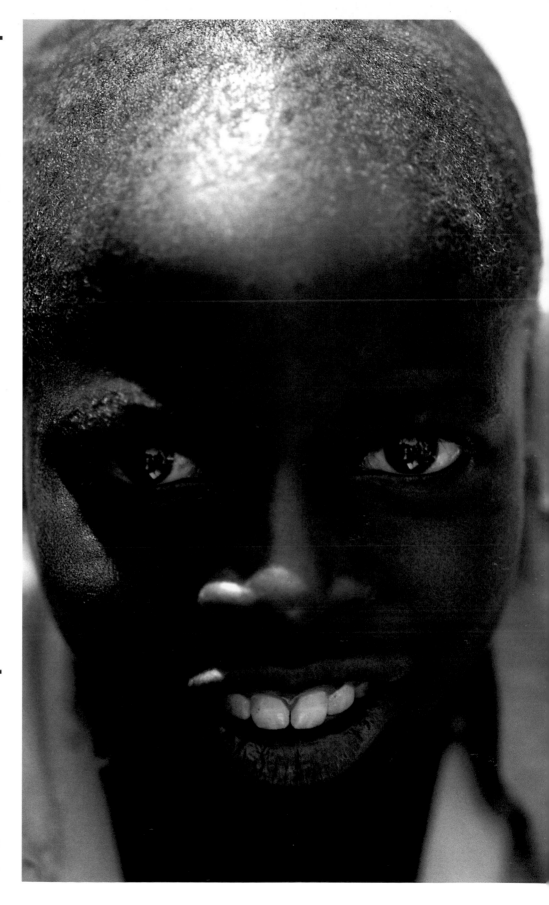

In addition to allowing us to study the human face in detail, close-ups can also help to overcome technical problems. In this example of a very dark Kenyan boy, a general light reading would have suggested a small aperture and brief shutter speed (or this would have been preset if on an automatic camera). But this would have resulted in a very underexposed subject, whereas a selective reading from the face would have given an overexposed background. Moving in close to crop out the background has solved this dilemma and produced a striking portrait.

PHOTOGRAPHER:
Bert Wiklund
CAMERA:
35mm
LENS:
**70–210mm zoom
(set at 135mm)**
FILM:
ISO 50
EXPOSURE:
**$\frac{1}{25}$ second
at f3.5**
LIGHTING:
Daylight only

Revealing the unseen

PHOTOGRAPHER:
Ted Clark
CAMERA:
6 x 4.5cm
LENS:
180mm
FILM:
ISO 50
EXPOSURE:
$\frac{1}{125}$ second at f8
LIGHTING:
Strobe flash (at $\frac{1}{35,000}$ second duration)

SOME OF THE LIMITATIONS OF THE HUMAN EYE – its inability to resolve very small details, for example, or to see the individual components that make up a fast-action sequence – can be overcome using a camera and various photographic and lighting techniques.

The fastest commonly available shutter speed on many good-quality cameras is around the $\frac{1}{2000}$ second mark. Some cameras offer $\frac{1}{4000}$ second as their fastest shutter speed or less, but even this tiny fraction of a second, during which time the shutter is open and the film is being exposed, may be too slow to reveal certain details or record what the eye cannot actually see in 'real time'. In situations such as this, rather than relying on the camera's ability to deliver sufficiently brief shutter speeds for your needs, you can use high-speed lighting units – sometimes referred to as strobes – instead. Some of these units can be programmed to deliver intense, short-duration bursts of light lasting a mere $\frac{1}{100,000}$ second or even less, which is brief enough to 'freeze' the fastest-moving object you are likely to have ready access to.

Not all photographic techniques for revealing subject detail rely on high-speed lighting, however. Sometimes, all you need to do is get in exceptionally close and thereby strip away the obvious outer layers and focus on an aspect of shape, texture, pattern or colour that would otherwise pass by entirely unnoticed. To achieve this, you have to be able to extend the lens much further forward of the camera body than the lens's normal focusing movement would allow.

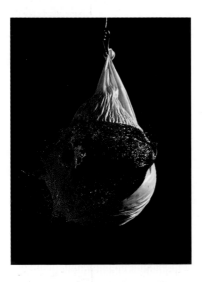 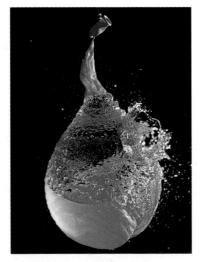 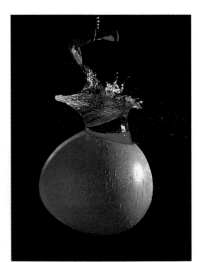

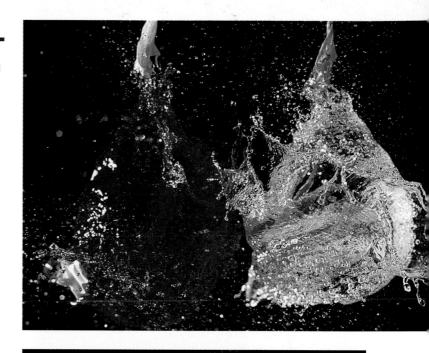

Pictures such as these and those opposite, taken at the precise instant the water-filled balloons are burst by being pierced with a dart, would be impossible to see with the unaided eye. Depending on the timing of the high-speed strobe, set to give a burst of light with a ⅟₃₅,₀₀₀ second duration, you can see the water still retaining its balloon shape before gravity takes over and ruptures the liquid's surface tension. You cannot move the camera physically near the balloons to get in close to the action, since when the water explodes outwards your equipment will be soaked. Instead, use a telephoto lens to bring the image up large in the frame and create maximum impact. Unless you use a remote infra-red trigger, or similar, to fire the shutter (and, simultaneously, the strobe) when the beam is broken by the dart you will have to make a best guess and fire the shutter manually. But firing the shutter this way will almost certainly result in a high percentage of unsuccessful images. Bear in mind that when using this type of lighting set-up, the shutter speed on the camera is important only in so far that it fires the strobe in synch with the shutter opening. For all practical purposes, it is flash duration and aperture that determine the film exposure.

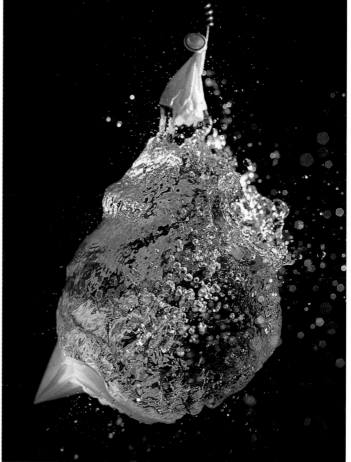

Using extension bellows between the camera body and lens, it was possible to move to within a few inches of this cereal seed-head to highlight the delicate yellows, pinks and shades of green contained within its structure. If it had been seen from any further distance away, this wealth of detail would pass entirely unnoticed. Working in a studio environment, organizing a black background to contrast with the subject does not represent a problem, as long as you ensure that any flats that may catch an overspill of light are distant and painted in a non-reflecting, matt-black colour.

PHOTOGRAPHER:
Bert Wiklund
CAMERA:
35mm (fitted with bellows)
LENS:
80mm
FILM:
ISO 64
EXPOSURE:
⅟₆₀ second at f22
LIGHTING:
Studio flash

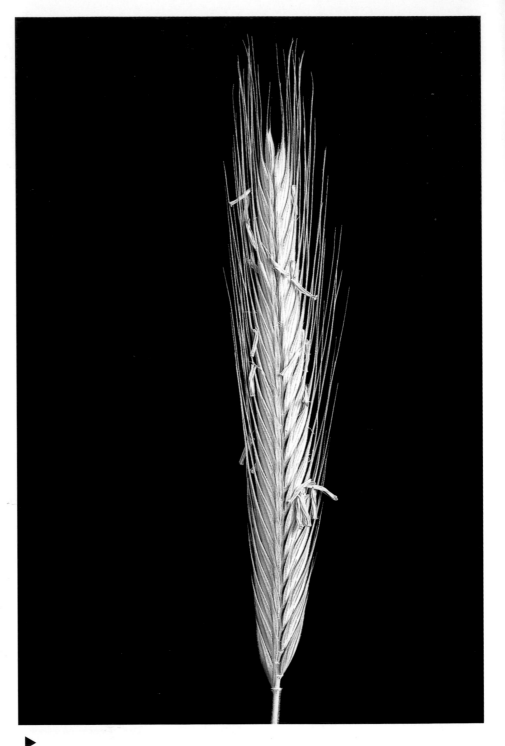

Bellows or extension tubes are essential for detailed close-ups of small subjects (see p. 13).

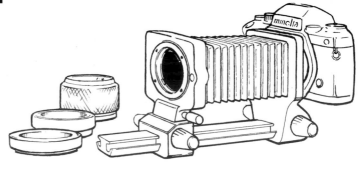

High-speed stroboscopic (strobe, for short) flash has not only 'frozen' this champagne cork rocketing out of it bottle, it has also fired at just the right moment to record the stream of gas and bubbles propelling its motion. This moment in real time would have lasted such a tiny fraction of a second that it could not consciously be registered, and the scene would have been wasted.

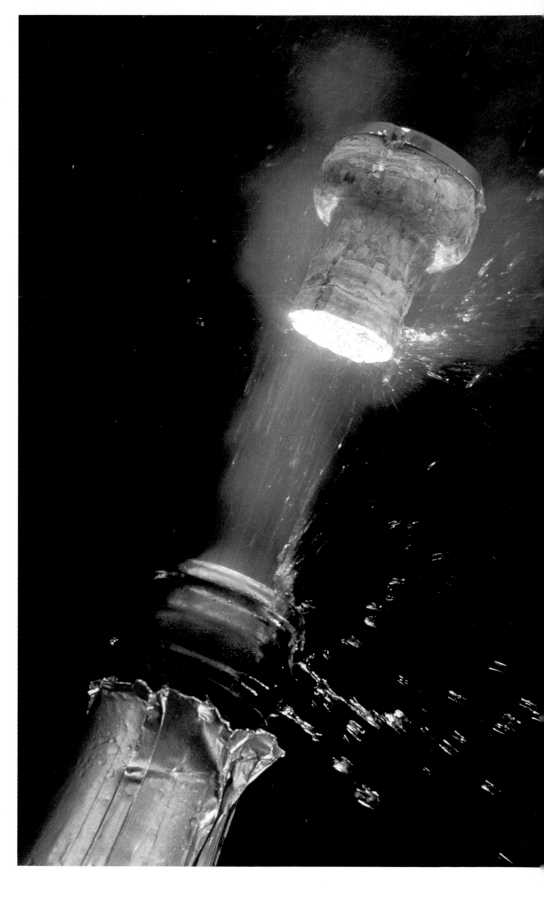

PHOTOGRAPHER:
Comstock/Mike Stuckey
CAMERA:
35mm
LENS:
180mm
FILM:
ISO 25
EXPOSURE:
$\frac{1}{20,000}$ second at f16
LIGHTING:
Strobe flash

PHOTOGRAPHER:
Comstock/Mike
Stuckey
CAMERA:
6 x 4.5cm
LENS:
180mm
FILM:
ISO 100
EXPOSURE:
1/30 second at f11
LIGHTING:
Daylight only

With subjects such as this plant seed-head, if working in extreme close-up outdoors, there is always a potential problem of subject movement should there be even the slightest breeze. The closer you are to the subject, or the larger the subject is in the viewfinder when you are using a long lens, then the more apparent subject (or camera) movement becomes on the final print or transparency. The depth of field associated with this type of close-up is always extremely shallow, and here the photographer has settled for a slightly soft fore-ground subject in order to retain a degree of defin-ition in the distant orb of the setting sun, which has been used so effectively to create a shape-emphasizing semi-silhouette.

Because even the slightest degree of subject movement could so irreparably spoil this type of close-up image, you need to ensure that the plant is protected from any hint of a breeze, using a windshield positioned out of the angle of view of the lens to create a pocket of still air. As an extra precaution, use a clamp, fixed low down on the plant's stem, to hold the specimen completely rigid.

▶

Filling the frame with this slightly underlit area of weathered wood concentrates the attention on its qualities of endurance and strength. The sidelighting, essential to illuminate the raised areas of grain and cast shadows into the cracks and crevices, describes the wood's texture and conveys a tangible sense of how the material would feel if you could reach out and touch it. If it had been seen from further back, this detail would have merged into a solid and homogeneous brown.

PHOTOGRAPHER:
Comstock/Mike Stuckey
CAMERA:
6 x 7cm
LENS:
220mm
FILM:
ISO 50
EXPOSURE:
⅙₀ second at f11
LIGHTING:
Tungsten floodlight and barn doors

2

FOCUSING ON PEOPLE

Close-up portraits

ONE OF THE KEY FEATURES THAT MAKES a successful portrait picture is the photographer's ability to record something of the subject's personality, rather than merely a simple likeness. Unless your subject is used to the limelight and responds well to the camera's presence (and the lighting equipment and other paraphernalia found in a typical studio), part of the photographer's job is to relax that person and to elicit a suitable range of facial expressions. As we are dealing here strictly with close-up portraits, appropriate body language is not as critical as it might otherwise be, since the face alone will probably be all that is seen.

One simple technique you can use to bring your subjects alive in front of the camera (for non-candid photography) is to engage them in conversation. Encourage them to talk to you about their interests, works, hobbies or whatever it is they like to do. If you fix your camera on a tripod after framing the shot, you will be able to move around more, keeping eye contact with them as you talk together. Other subjects may prefer to have music playing, so keep a good range of different types of music in the studio. Others, of course, might hate music playing during the session, and so you need to be flexible in your approach.

Candid close-ups do not give you the opportunity to manipulate the appearance of your subjects to the same degree, and instead you must rely on good timing, patience and an element of luck to capture that telling portrait.

▼

Two studio flash units were used to light this portrait. The main unit (direct, undiffused flash) was positioned far to the left of the camera position so that its light raked across the subject at about a 45° angle. The second flash unit was fitted with a scrim and positioned further back and to the right of the camera position.

PHOTOGRAPHER:
Linda Sole
CAMERA:
6 x 4.5cm
LENS:
120mm
FILM:
ISO 100
EXPOSURE:
¹⁄₆₀ second at f22
LIGHTING:
Studio flash x 2 (one fitted with a scrim)

▶

The photographer had a bit of an advantage in trying to relax the subject of this picture – she is her own daughter, and is well used to acting as a model for her mother. In close-up portraits in particular, a subject's hair can often be used to good effect in order to frame the face.

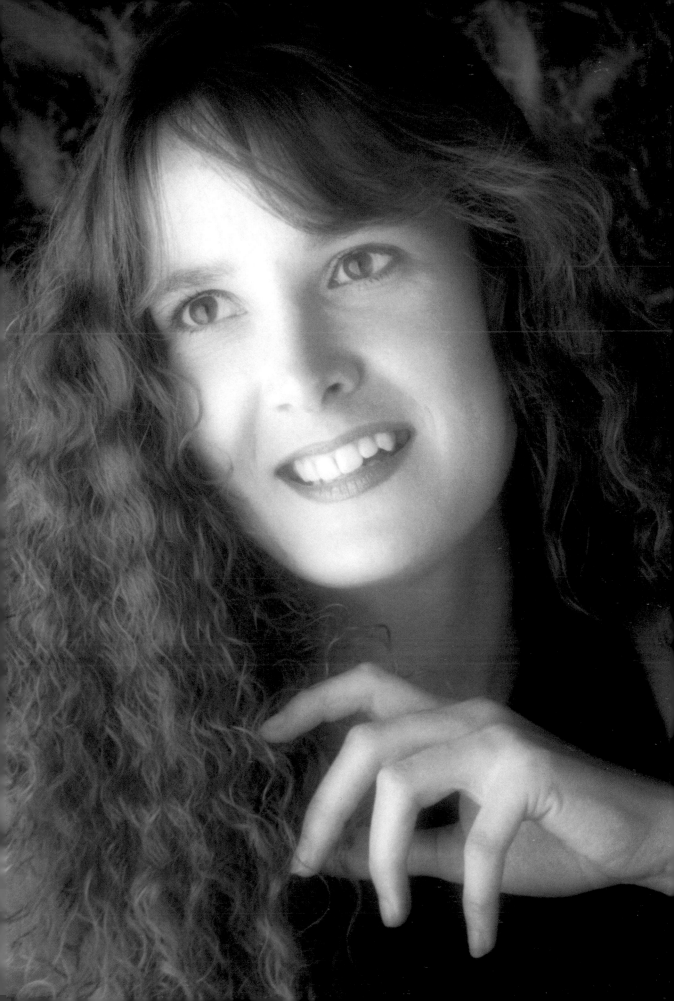

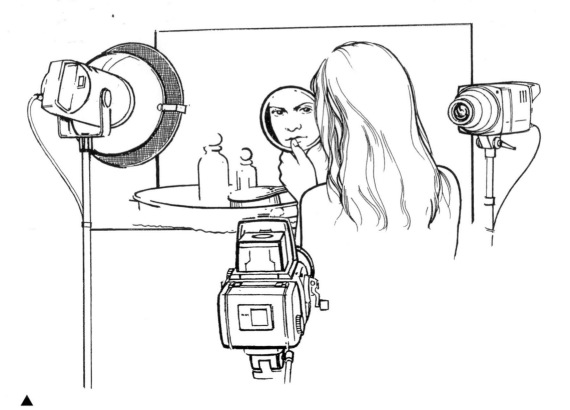

To achieve the brightly lit face seen in the mirror, a studio flash fitted with a snoot was positioned in front of the subject. The snoot narrows and confines the light output, but enough spilled over to produce the slight halo effect visible around the subject's shoulder and the edge of her hair. Placement of this light was crucial, since if any of the flash-light had reached the camera lens directly it would have caused image-degrading flair. The second light, heavily diffused with a scrim and powered down to only a third of the power of the other, was placed to the left of the camera position. Its principal function was to light the subject's back sufficiently to prevent it being lost in heavy shadow.

PHOTOGRAPHER:
Comstock/Tom Grill
CAMERA:
6 x 4.5cm
LENS:
120mm
FILM:
ISO 50
EXPOSURE:
⅟₆₀ second at f4
LIGHTING:
Studio flash x 2 (one fitted with a diffusing scrim, one with a snoot)

▶

In this unusual approach to a close-up portrait, the photographer has used a small hand-mirror to provide us with the only view of the woman's face. The soft and romantic atmosphere the picture conjures up has been helped by the use of a soft-focus filter. The lighting is a mixture of front- and backlighting.

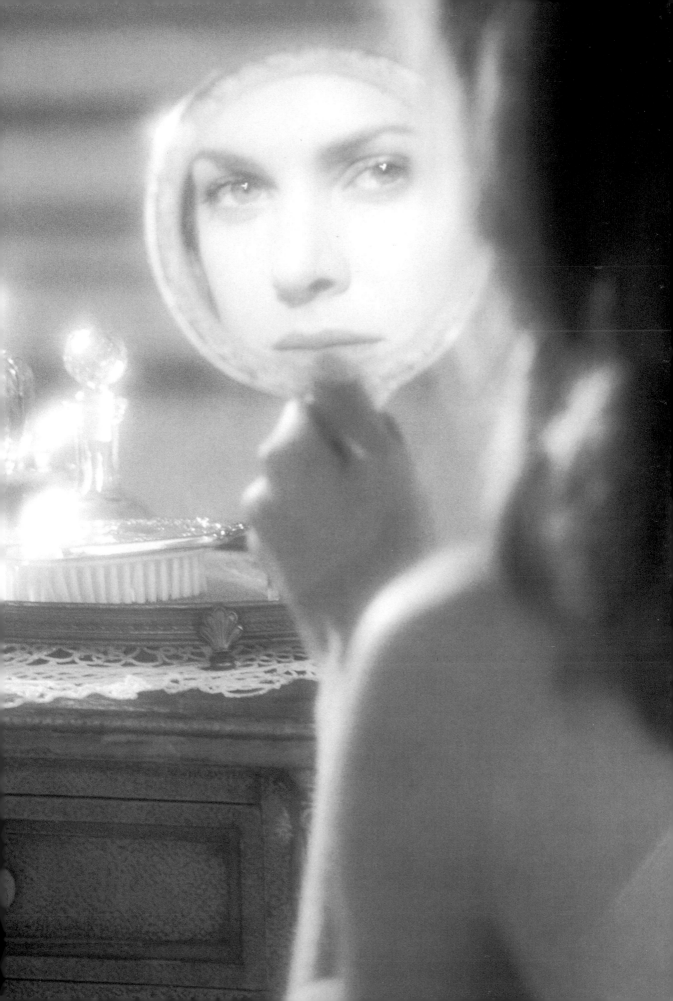

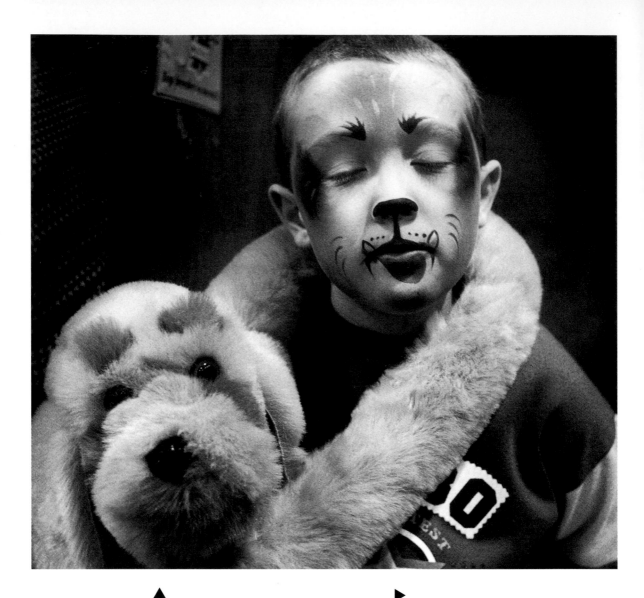

▲

PHOTOGRAPHER:
Linda Sole
CAMERA:
6 x 6cm
LENS:
180mm
FILM:
ISO 400
EXPOSURE:
1/125 second at f8
LIGHTING:
Daylight only

Taken in the late afternoon at Crufts, the international dog show held annually in London, this canine fan, especially made-up with face-paint for the occasion, could not keep his eyes open any longer. Working from the periphery of the crowd of milling spectators at the show, the photographer could take her time composing the shot, safe in the knowledge that the subject was not going to notice her.

▶

By looking directly into the lens, the young subject here is firmly engaging the viewer. By selecting a large lens aperture, the photographer has ensured that the side of the face of the foreground subject is enough out of focus not to compete, yet sufficiently discernible not to distract.

PHOTOGRAPHER:
Comstock/Mike Stuckey
CAMERA:
35mm
LENS:
135mm
FILM:
ISO 200
EXPOSURE:
1/60 second at f2.8
LIGHTING:
Daylight and accessory flash

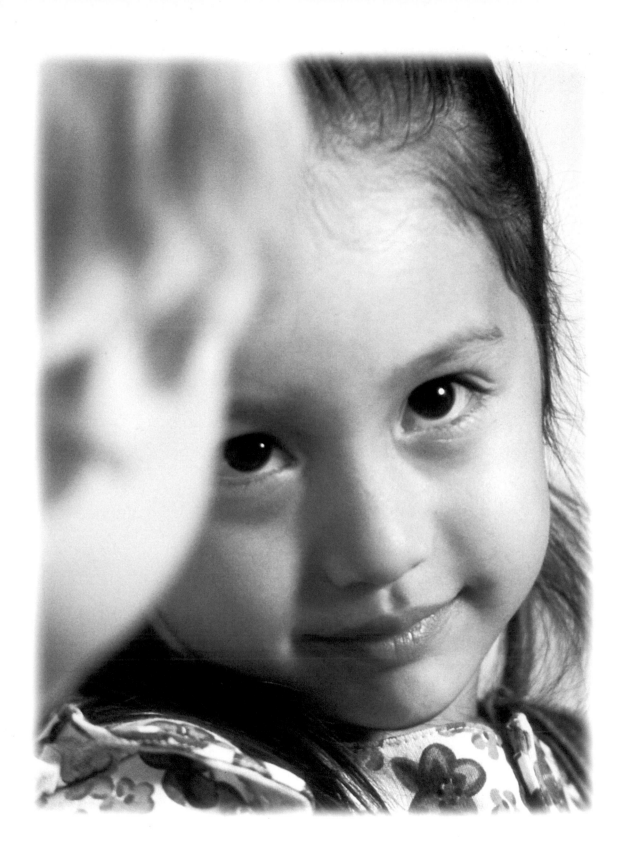

If you want the subject to remain completely natural and unaware of the camera, then you need to hang well back out of the way. It also helps if you use a long lens to lend a little distance while still filling the frame with a good-sized close-up portrait. You must also work quickly, because you will soon become obvious, even to the most unobservant subject, if you have a camera raised to your eye for any length of time.

PHOTOGRAPHER:
Linda Sole
CAMERA:
35mm
LENS:
70–210mm zoom (set at 210mm)
FILM:
ISO 200
EXPOSURE:
½₅₀ second at f5.6
LIGHTING:
Daylight only

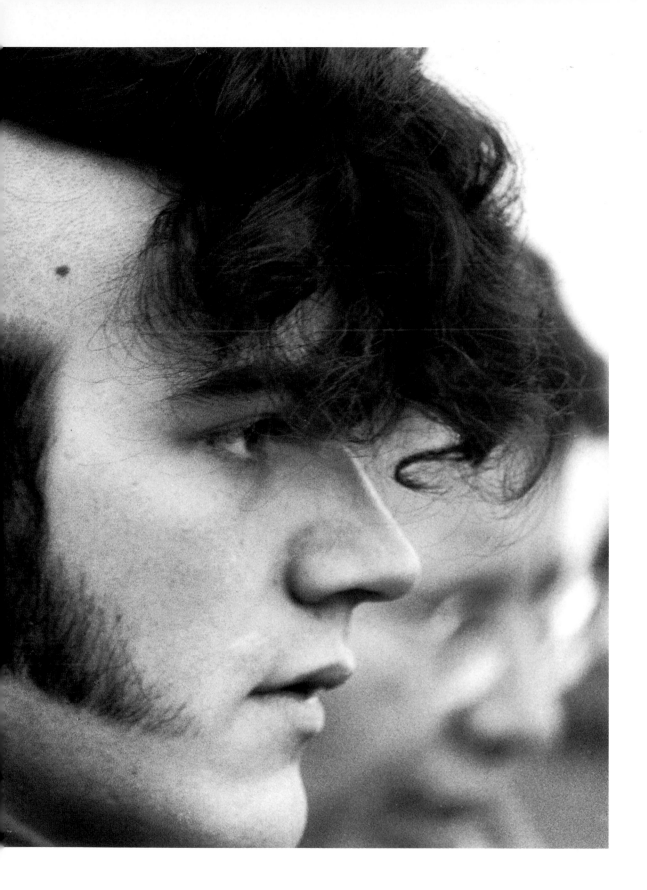

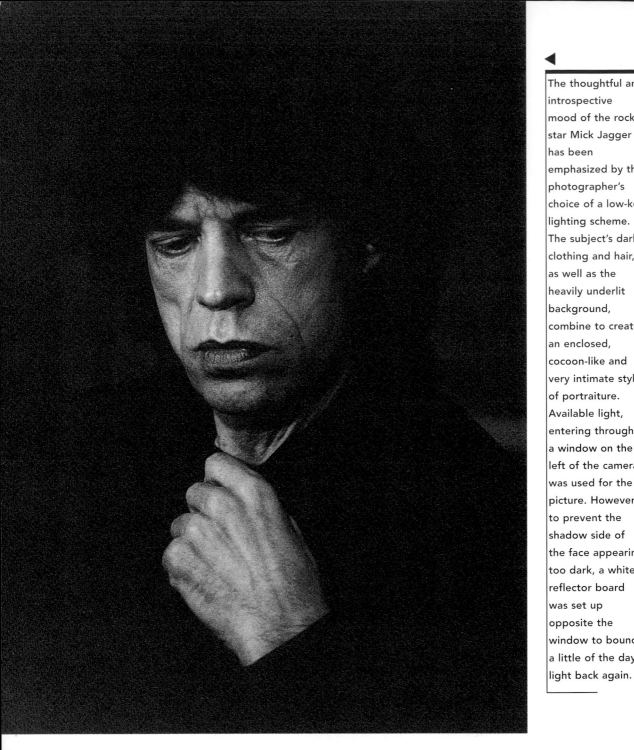

The thoughtful and introspective mood of the rock star Mick Jagger has been emphasized by the photographer's choice of a low-key lighting scheme. The subject's dark clothing and hair, as well as the heavily underlit background, combine to create an enclosed, cocoon-like and very intimate style of portraiture. Available light, entering through a window on the left of the camera, was used for the picture. However, to prevent the shadow side of the face appearing too dark, a white reflector board was set up opposite the window to bounce a little of the daylight back again.

PHOTOGRAPHER:
Linda Sole
CAMERA:
35mm
LENS:
90mm
FILM:
ISO 400

EXPOSURE:
⅟₆₀ second at f5.6
LIGHTING:
Daylight only (and reflector board)

It is possible to take a completely natural close-up portrait, yet one that is carefully composed and lit, if the subject is thoroughly engrossed in some type of activity. Here, the photographers have chosen this man's workshop as the setting for the shot. Fully occupied in carving an intricate piece of decorative woodwork, he appears oblivious of the camera. Lit by two flash units, their heads angled so that little light spills beyond the subject, the background is heavily underlit and has been almost totally suppressed.

PHOTOGRAPHER:
**Comstock/
Mike and Carol
Werner**
CAMERA:
6 x 4.5cm
LENS:
180mm
FILM:
ISO 100
EXPOSURE:
1/25 second at f5.6
LIGHTING:
Accessory flash x 2

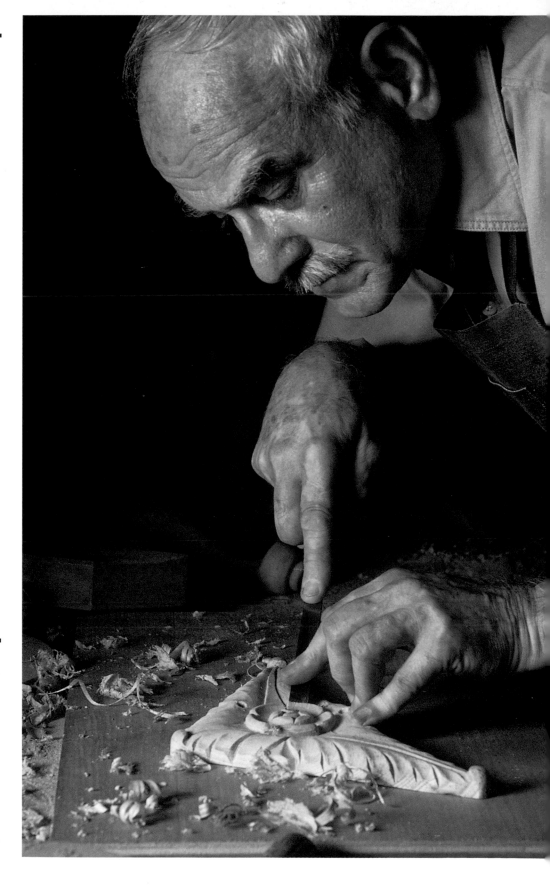

The human form

FOR ARTISTS, WHETHER SCULPTORS OR THOSE working with paint, pencil or charcoal, the human form has been a source of inspiration since the earliest of recorded times. And with the inception of photography toward the end of the 19th century, those early practitioners – influenced as they inevitably were with the established art forms and subject matter – often posed their subjects in the manner of the 'classical nude', in studio sets that were reminiscent of those in the canvases of contemporary and earlier artists. It didn't take long, however, for photographers – working with increasingly sophisticated cameras, lenses and emulsions – to start exploring the potential of this new medium as a distinct art form. Photography is, indeed, distinct from any other form of artistic endeavour, for rather than showing a symbolic representation of the subject, it has the ability to record, through the direct action of light alone, a frozen instant of reality.

Working with an inexperienced nude model or a model you do not know, may bring with it some embarrassment. Don't forget that it is quite normal for people to feel vulnerable when naked in the company of a clothed person who is taking pictures of them. Do all you can to make them feel comfortable and at ease in the situation, while concentrating all the time on using light – natural, artificial or a combination of both – camera angle, facial expression and body language to show the subject's shape and form to best advantage.

WORKING WITH NUDE MODELS

- If you are working outdoors, ensure that you have complete privacy from roads and paths and neighbouring properties.
- Models should wear loose-fitting underwear and clothing before the photo session to avoid marking their skin with elastic waist-bands, etc.
- Indoors, ensure the studio is comfortably warm. Seen in close-up, skin covered in goose-bumps looks unattractive.
- Never insist that a model adopts a pose he or she feels uncomfortable doing.
- Try to vary lighting effects as much as possible throughout the session – try the extremes of high-key and low-key lighting, as well all the variations in between.
- Experienced nude models, especially when working with inexperienced photographers, may simply want to adopt the standard types of poses they have used countless times before. If this is not what you want to achieve during the session, insist that they follow your directions.

When seen in extreme close-up, the human form can take on a strange, abstract quality. Raking sidelighting has been used to exaggerate the skin texture here, and with deep shadows and bright highlights producing a satisfying level of contrast, there are still plenty of subtle half-tones to define shape and form.

PHOTOGRAPHER:	EXPOSURE:
Simon Hennessey	**$\frac{1}{125}$ second**
CAMERA:	**at f11**
35mm	LIGHTING:
LENS:	**Studio flash**
180mm	
FILM:	
ISO 200	

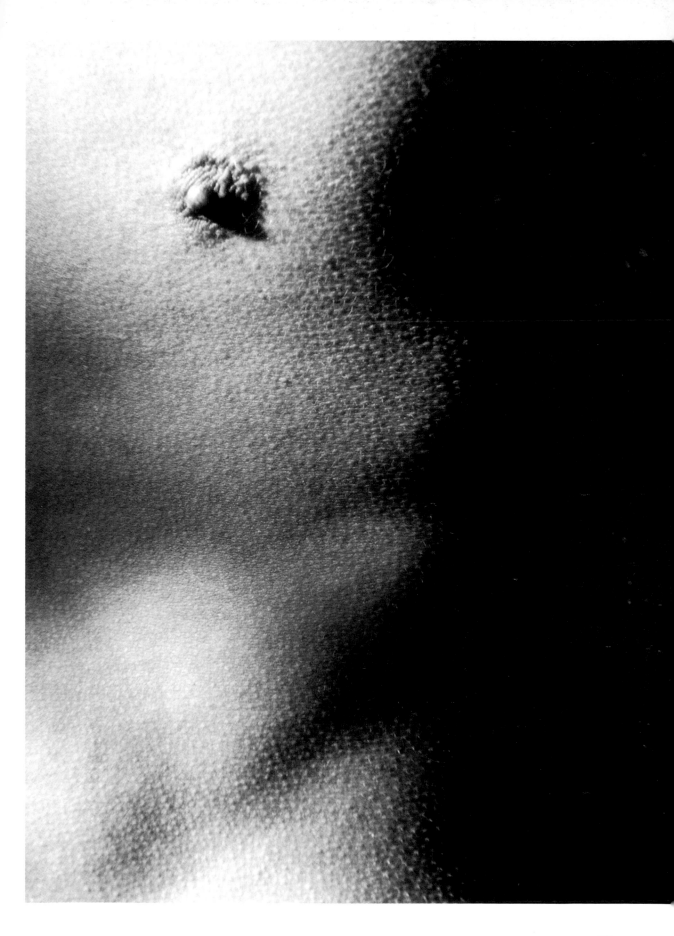

To help define this model's already well-developed musculature even more strongly, a light coating of massage oil was rubbed into his skin. When using oil like this, make sure that over-intense, localized highlights, or hot spots, don't occur.

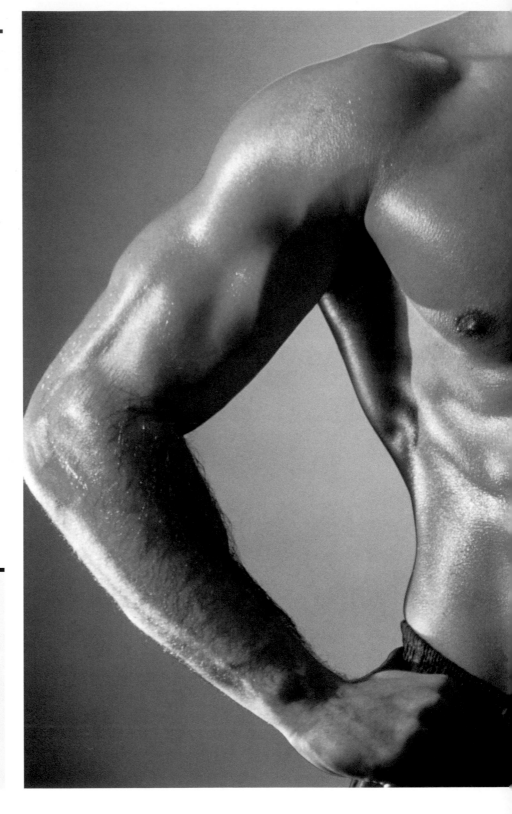

PHOTOGRAPHER:
Comstock/Mike Stuckey
CAMERA:
6 x 4.5cm
LENS:
105mm
FILM:
ISO 50
EXPOSURE:
$\frac{1}{125}$ second at f16
LIGHTING:
Studio flash x 2

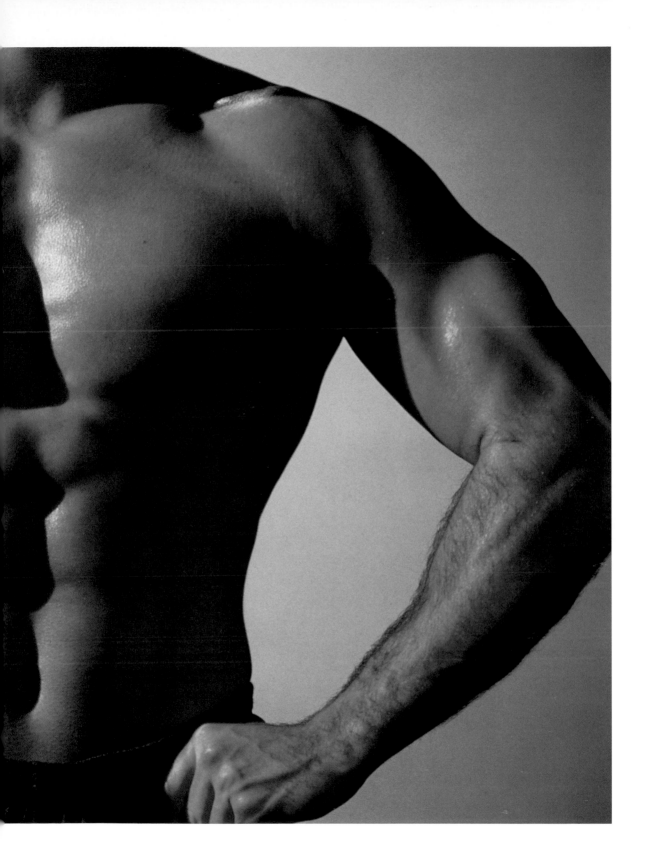

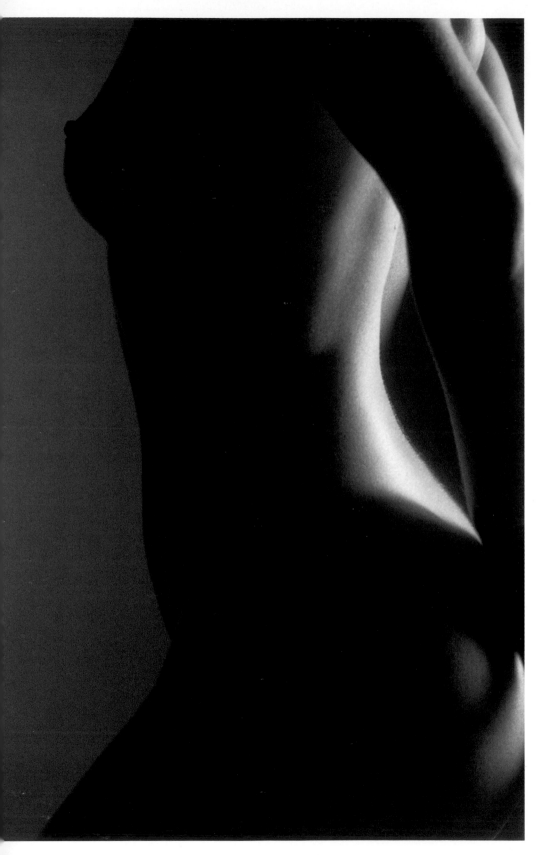

Using just a single, undiffused studio flash unit, the photographer has represented the subject as either lit or unlit surfaces, with only a restricted area of shading at the conjunction of the lit and shaded areas. The light unit was fitted with barn doors to control the spread of light and prevent it spilling past the figure. The only other lighting has been used well away from the subject, directed at the background, and reflecting back sufficient illumination to show the subject's thigh, torso and breast in silhouette.

PHOTOGRAPHER:
Comstock/Tom Grill
CAMERA:
6 x 4.5cm
LENS:
120mm
FILM:
ISO 100
EXPOSURE:
1/60 second at f16
LIGHTING:
Studio flash x 2 (one fitted with barn doors)

Studio flash units, with their heads specially masked down with opaque material in order to create small, well-defined highlights, were used to take this romantic close-up. Also, a soft-focus lens was used to accentuate the rounded shapes of the subjects' faces and this has caused a slight flaring of the highlight on the woman's lips.

PHOTOGRAPHER:
Comstock/Tom Grill
CAMERA:
35mm
LENS:
90mm (soft-focus lens)
FILM:
ISO 50
EXPOSURE:
⅟₆₀ second at f5.6
LIGHTING:
Studio flash x 2

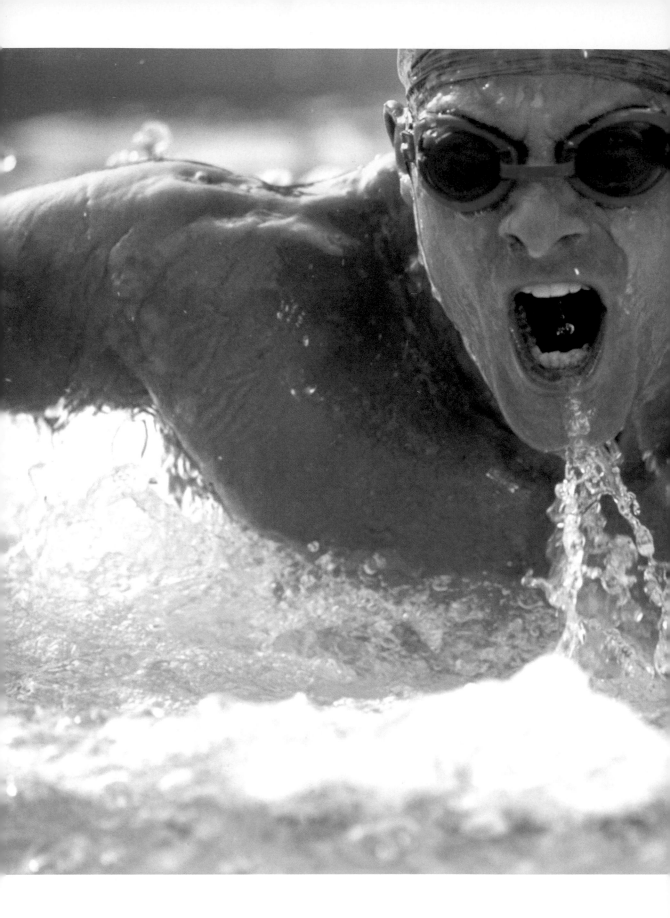

There are different ways the human form can be depicted, as this shot of a swimmer, heaving himself out of the water to suck in a breath, demonstrates. Using a long lens from the spectators' stand, depth of field is minimal, which is less of a problem that it might otherwise have been because of the photographer's head-on camera angle to the subject.

PHOTOGRAPHER:
Comstock/Tom Grill
CAMERA:
35mm
LENS:
350mm
FILM:
ISO 100
EXPOSURE:
1/1000 second at f5.6
LIGHTING:
Daylight only

Depth of field

THE CLOSER YOU WORK TO YOUR SUBJECT, either by moving physically close or by using a long lens to bridge the gap, the less depth of field you have. Depth of field is the zone of acceptably sharp focus that exists both in front of and behind the point you actually focus the lens on.

This zone is variable and is dependent on, essentially, three factors.

- First, the lens aperture you select: the smaller the aperture (i.e.,. larger aperture numbers – f11 is a smaller aperture than f5.6), the greater the depth of field.
- Second, the focal length of the lens (or setting on a zoom): the shorter the lens (i.e., a wide-angle as opposed to a telephoto lens or zoom setting), the greater the depth of field at any given aperture.
- Third, the lens-to-subject distance: the further away you focus the lens, the greater the depth of field at any given aperture or on any given focal length lens.

In some branches of extreme close-up photography, more specialist equipment, such as bellows and extension tubes, are fixed between the lens and camera body to allow you to focus much closer than would normally be possible. When using this type of equipment, the depth of field may be so shallow that only part of the subject can be sharply rendered. If you are confronted with this type of problem, you must select which part of the subject will appear sharp, and which unsharp. Cameras that have a depth of field preview button will manually close the aperture down to that selected for exposure – allowing you to see (with a reasonable degree of accuracy) on the focusing screen what is and what is not in focus before you shoot.

Even if you are working with non-specialist equipment such as, say, a 200mm lens, you may still have to be careful that the depth of field at maximum aperture and at the closest focusing distance is sufficient to render your subject sharp overall. If your subject is a person's face, then the usual advice is to take particular care that the eyes are critically sharp – the rest of the face is less important.

The limitations of depth of field in close-up photography are well illustrated in this picture, but you can see that a shallow zone of sharp focus can be used to your advantage. By focusing precisely on the baby's hand clasping the adult's thumb, a sense of scale has been established that implies the fragility and dependency of the infant. At the same time, the out-of-focus image of the baby's face retains just sufficient clarity for it to be recognizable.

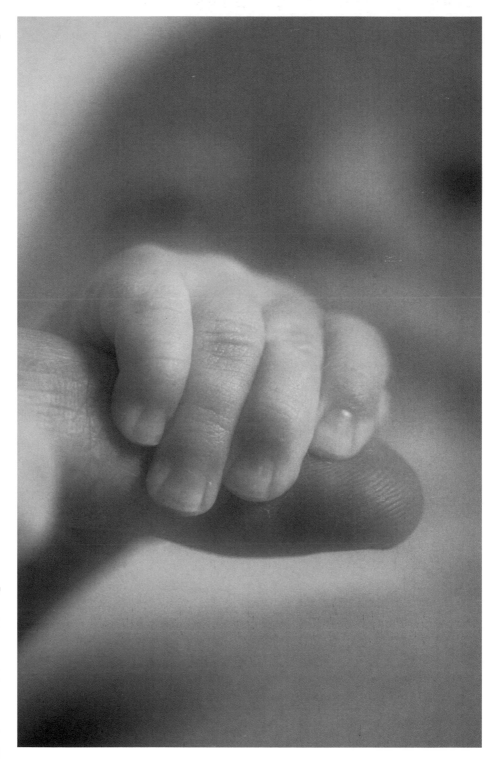

PHOTOGRAPHER:
Comstock/Mike Stuckey
CAMERA:
35mm
LENS:
55mm macro
FILM:
ISO 50
EXPOSURE:
⅙₀ second at f22
LIGHTING:
Daylight and bounced accessory flash

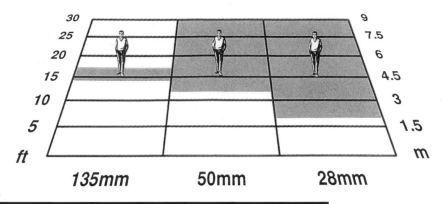

135mm 50mm 28mm

▲

This diagram illustrates the effects on depth of field brought about by using three very common focal length lenses. In each case, the lens aperture remained constant at f8.

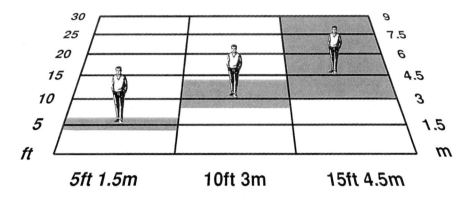

5ft 1.5m 10ft 3m 15ft 4.5m

▲

For the purposes of this illustration, changes in depth of field are the result of changing only the distance between the camera and the subject. In each case, the lens is a standard (for 35mm cameras) 50mm optic and the aperture is f8.

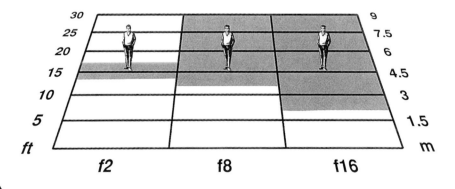

f2 f8 f16

▲

Here you can see the depth of field changes brought about by changing only the lens aperture on the same focal length lens. The largest aperture produces the shallowest depth of field, while the smallest gives the most extensive.

▲

Using what is often called a portrait lens
(90mm on a 35mm camera), depth of field
in this shot is so shallow that not all of the
adult's hand is in focus. Also, notice how
soft the baby's leg becomes as soon as
you look beyond its tiny foot. The actual
point of focus here was on the baby's
little toe.

PHOTOGRAPHER:
**Comstock/Tom
Grill**
CAMERA:
35mm
LENS:
90mm
FILM:
ISO 50
EXPOSURE:
⅟₆₀ second at f4
LIGHTING:
**Studio flash fitted
with snoot**

3

ARCHITECTURE IN DETAIL

Features and detailing

Even if a building has no overall architectural merit, there may be areas of detailing or specific features that suggest the whole and would make a worthwhile photograph. And never forget just how important lighting quality is to your subject. For example, a relief design or motif viewed by direct, frontal lighting may appear dull and uninteresting. An hour or two later, however, and the sunlight may strike that same feature from a more oblique angle, and suddenly what was unremarkable becomes a subject that demands attention. Concentrating on small features and details is also a practical approach to architectural photography when, because of the building's setting, perhaps, or because you don't have the right equipment, including the whole building in the frame is simply not possible.

USING FLASH

Artificially lighting an entire building, or even a worthwhile portion of it, is out of the question for the averagely equipped photographer, but this is not the case if you limit the picture frame to small features only. This, to a degree, makes you less than totally reliant on the vagaries of natural light. If combining artificial light and daylight, however, align your flash or other lighting unit with the direction of the natural light. If you do otherwise, you run the risk of introducing conflicting or confusing shadows.

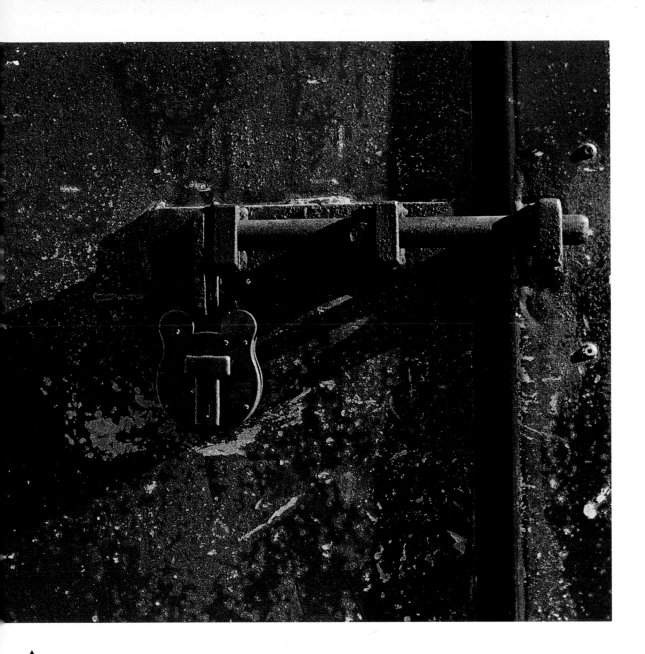

▲

In this example, the shadows cast by a low afternoon sun are just as much the subject of the photograph as the padlock and locking device. It is the adjacent lit and unlit areas of the door and lock that give the photograph its sense of depth, and the scarred metalwork and chipped paint its character.

PHOTOGRAPHER:
Simon Hennessey
CAMERA:
35mm
LENS:
80mm
FILM:
ISO 200
EXPOSURE:
**½₅₀ second
at f11**
LIGHTING:
Daylight only

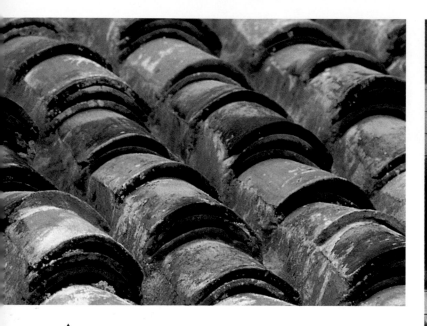

▲

Already hundreds of years old, and showing the scars inflicted on them by the elements, as well as the attentions of the local bird population, these hand-formed roofing tiles seen here in close-up perfectly evoke the atmosphere of the Mediterranean. As long as you allow yourself to 'see' the environment around you, rather than just look at it, the selective view of the camera frees your imagination to create imagery with universal appeal.

PHOTOGRAPHER:
Comstock/Franklin Viola
CAMERA:
35mm
LENS:
135mm
FILM:
ISO 100
EXPOSURE:
⅟₆₀ second at f5.6
LIGHTING:
Daylight only

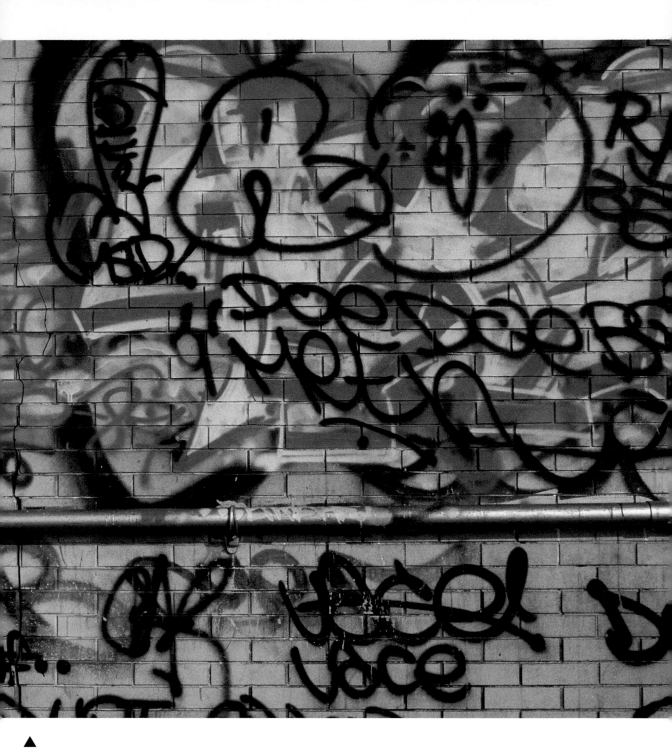

▲

This type of scene is an increasingly common feature of modern urban life – is it art or is it vandalism? No matter how you regard it, graffiti has become such a significant feature that images such as this will become an important part of the cultural record of our age.

PHOTOGRAPHER:	EXPOSURE:
Comstock/Tom Grill	⅟₆₀ **second at f11**
CAMERA:	LIGHTING:
6 x 7cm	**Daylight and**
LENS:	**diffused accessory**
120mm	**flash**
FILM:	
ISO 50	

Even if the whole building is not particularly appealing, a selective view such this, of just one edge, showing alternating panels of beige and brown partly reflected in the bowed glass façade, makes an attractive image. The flat and featureless blue of the sky adds to the abstract interpretation the photographer has produced.

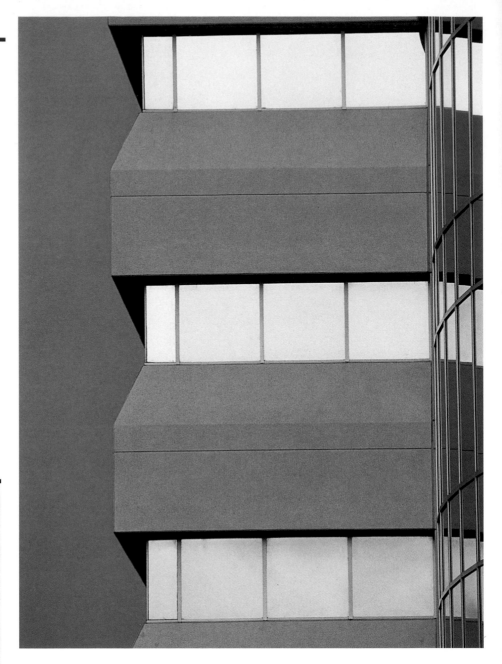

PHOTOGRAPHER:
Comstock/Bob Pizaro
CAMERA:
35mm
LENS:
300mm
FILM:
ISO 50
EXPOSURE:
1/500 second at f11
LIGHTING:
Daylight only

PHOTOGRAPHER:
Comstock/Gary Benson
CAMERA:
6 x 7cm
LENS:
200mm
FILM:
ISO 200
EXPOSURE:
1/125 second at f11
LIGHTING:
Daylight only

It is surprising how infrequently we bother to look up above the ground-floor level of buildings, and so it is even more surprising that, when we do, we often find a wealth of architectural detail to be photographed. This Gothic-inspired gargoyle was photographed from a building opposite. If it had been taken with a long lens from ground level, only a far more restricted view of the creature would have been possible to achieve.

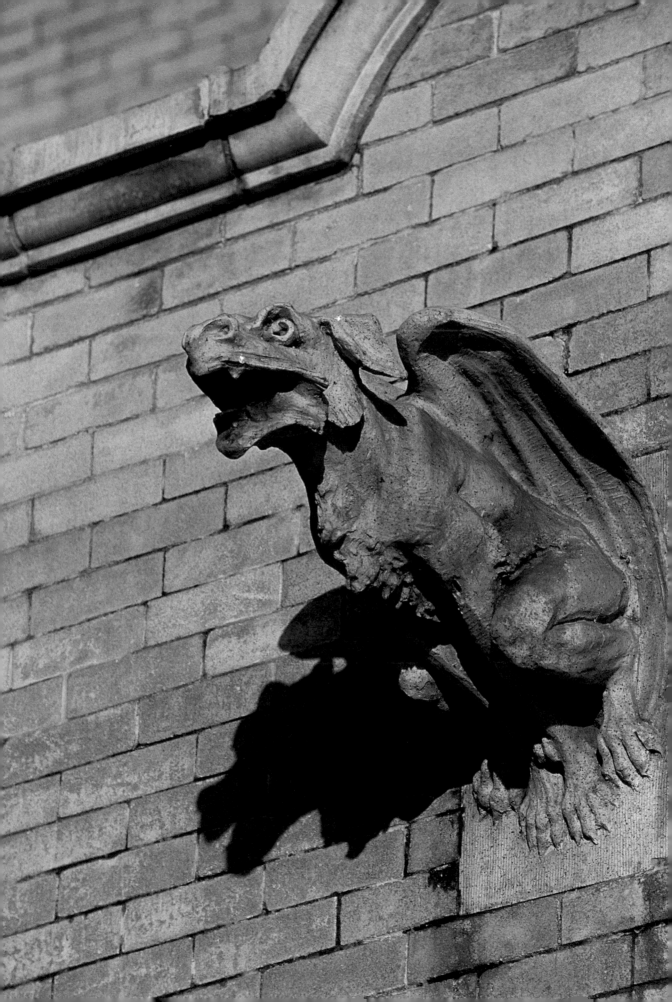

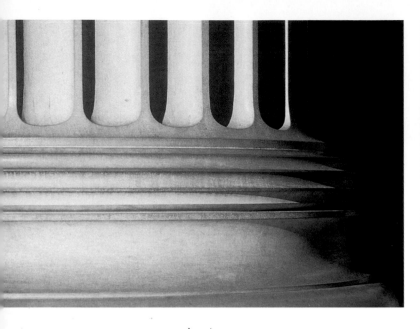

▲ ▶

PHOTOGRAPHER:
**Comstock/Mike
Stuckey**
CAMERA:
35mm
LENS:
50mm
FILM:
ISO 50
EXPOSURE:
**½₅₀ second
at f16**
LIGHTING:
Daylight only

In city centres, it is almost impossible to move far enough back to take in a whole structure, so you need critically to select those parts of your chosen subject that are most representative of the whole structure. By closing in on just a detail you can also exclude cars, people and all the other clutter that could mar the final picture. In addition, though the lighting overall may be unsatisfactory, for the bottom of a pillar, for example, or an elaborately carved pediment, the illumination may be just perfect.

PHOTOGRAPHER:
**Comstock/Jack
Elness**
CAMERA:
6 x 4.5cm
LENS:
100mm
FILM:
ISO 100
EXPOSURE:
½₆₀ second at f16
LIGHTING:
Daylight only

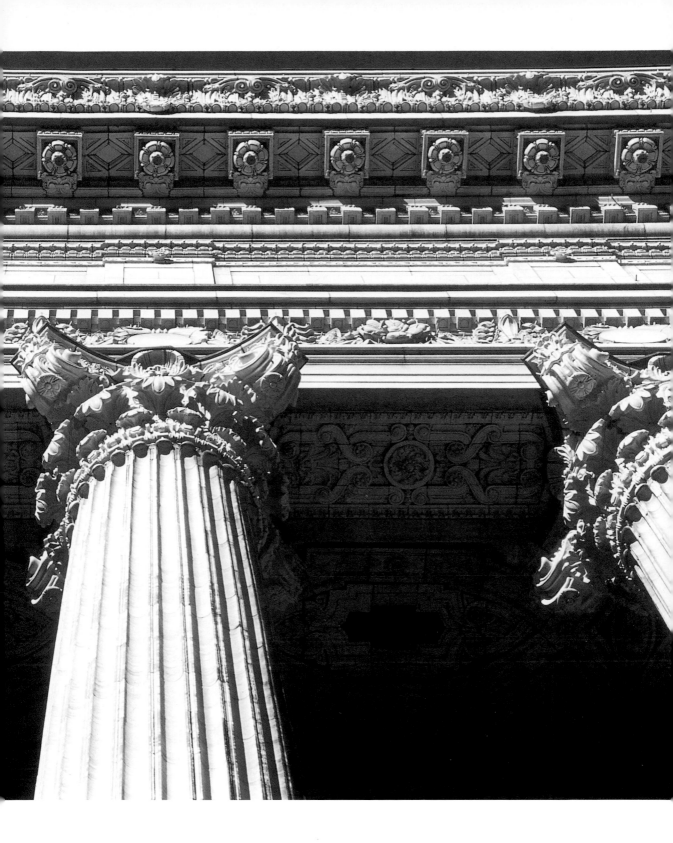

Sometimes, a detail is all there is to photograph. In the grounds of an Italian palazzo, the photographer came across this remnant of what once must have been a statue of enormous proportions. Unable to resist introducing a little humour into the shot, he purposely moved in close to the toes of the foot and used a wide-angle lens to exaggerate the front-to-back perspective.

PHOTOGRAPHER:
Comstock/Mike Stuckey
CAMERA:
35mm
LENS:
70–210mm zoom (set at 160mm)
FILM:
ISO 100
EXPOSURE:
1/30 second at f22
LIGHTING:
Daylight only

PHOTOGRAPHER:
Bert Wiklund
CAMERA:
6 x 6cm
LENS:
50mm
FILM:
ISO 50
EXPOSURE:
1/500 second at f8
LIGHTING:
Daylight only

If this picture had been framed so that the entire doorway could be seen, then the exquisitely carved and detailed marble surround would barely have been noticeable. As it is, we can explore the workmanship at our leisure and marvel at the skills that have now been largely lost or neglected.

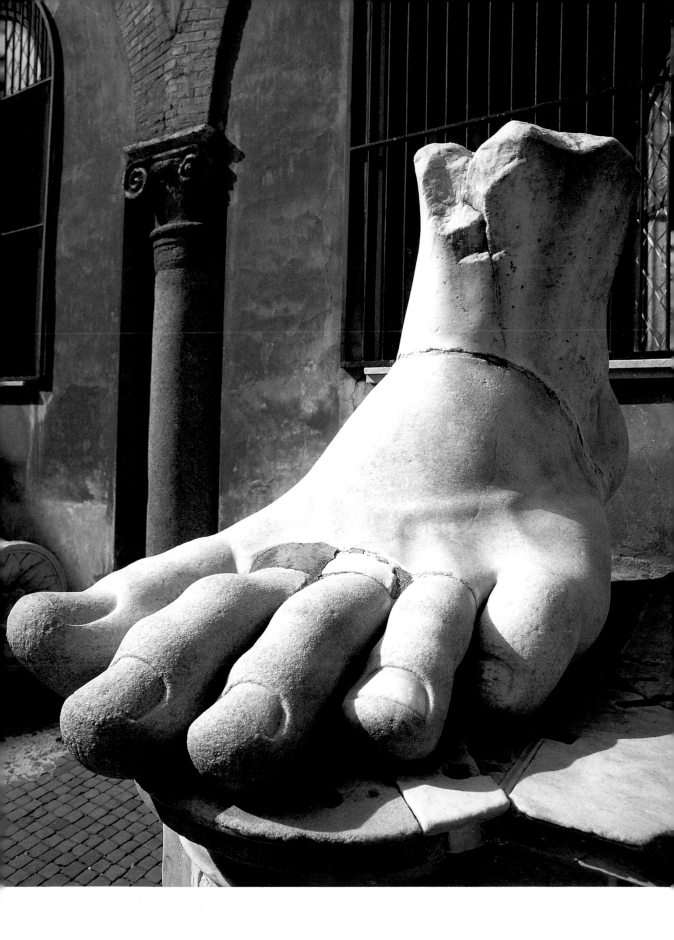

Colour for impact

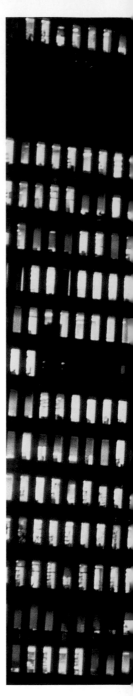

Colour is an often surprising feature of many styles of architecture. Often, of course, it may be only a small part of a building that exhibits intentional colour, and it is only by adopting the most telling camera position and using the appropriate lens to take just an isolated close-up of a particular part that you can skew the emphasis to suit your photographic requirements.

However, since architectural photography relies so heavily on natural daylight – which, by its very nature, changes dramatically in colour content not only at different times of the day, but also a different times of the year according to the season and the prevailing weather – buildings can sometimes take on the most unexpected and photogenic hues.

▶

PHOTOGRAPHER:
Comstock/Carlos Valdes-Dapena
CAMERA:
6 x 7cm
LENS:
600mm
FILM:
ISO 50
EXPOSURE:
⅕s second at f11
LIGHTING:
Domestic tungsten and fluorescent

This shot is 'close-up' in the sense that these buildings were shot with a long lens to record just slices of their façades. The colour in the picture comes from a mismatch of light source and the type of film used, which was designed to record accurate colour in daylight or with electronic flash, which have the same colour temperature. The predominant tungsten and fluorescent nature of the lighting within the offices has imparted a strongly warm colouration to the composition.

Although only a
small portion of
the structure has
been recorded, the
colours and shapes
tell us instantly
that we are looking
at an Art Deco
building, dating
from sometime in
the 1930s.

PHOTOGRAPHER:
**Comstock/Jack
Elness**
CAMERA:
35mm
LENS:
85mm
FILM:
ISO 50
EXPOSURE:
**⅟₆₀ second
at f5.6**
LIGHTING:
Daylight only

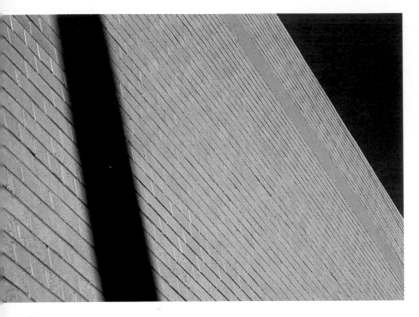

▲

PHOTOGRAPHER:
Paul Kirk
CAMERA:
35mm
LENS:
35mm
FILM:
ISO 64
EXPOSURE:
**½₅₀ second
at f11**
LIGHTING:
Daylight only

If you keep alert to the detail around you, you will never be short of photographic subjects. Here, the photographer has turned what is an ordinary, everyday subject of a part-painted brick wall into an eye-catching image by contrasting the sunshine yellow of the top part of the wall with the deep blue of the sky, and angling the camera to produce a strongly diagonal composition that manages to impart movement and vitality to this most inanimate of subjects.

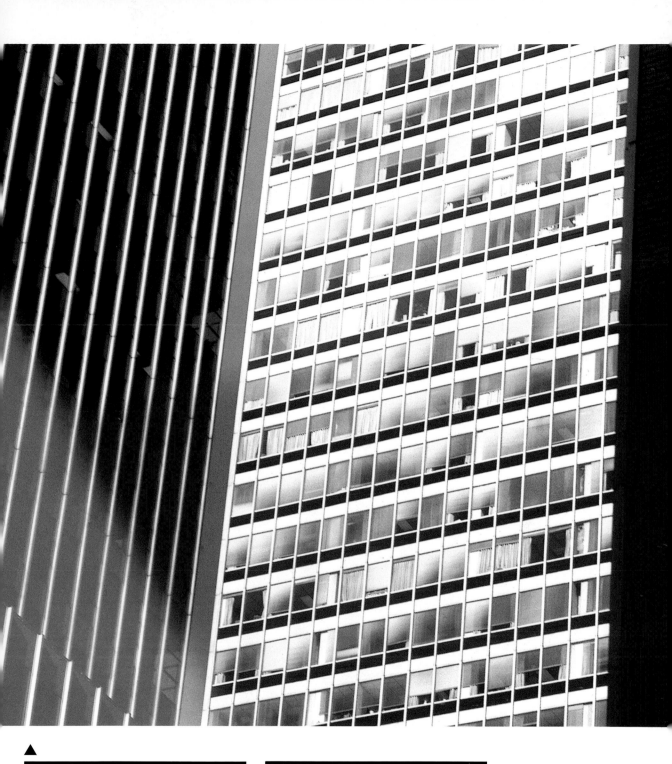

By carefully aligning coloured reflections on the inside of the glass the photographer was shooting behind with different areas of the scene beyond the window, the cityscape outside has been transformed. For this type of effect to be more than a hit-and-miss affair, you need to work with the framing accuracy provided by the viewfinder of a single lens reflex camera.

PHOTOGRAPHER:	FILM:
Paul Kirk	**ISO 64**
CAMERA:	EXPOSURE:
35mm	**⅟₆₀ second**
LENS:	**at f22**
70–210mm zoom	LIGHTING:
(set at 190mm)	**Daylight only**

▲

The colour impact of this close-up shot is almost vibrant, and it eloquently makes the point that good pictures have everything to do with the imagination of the photographer.

PHOTOGRAPHER:
Paul Kirk
CAMERA:
35mm
LENS:
28mm
FILM:
ISO 64
EXPOSURE:
1/60 second at f8
LIGHTING:
Daylight only

PHOTOGRAPHER:
Madeleine Hilton
CAMERA:
35mm
LENS:
28–70mm zoom (set at 70mm)
FILM:
ISO 200
EXPOSURE:
1/125 second at f16
LIGHTING:
Daylight only

▶

A ship-board swimming pool, seen here empty of water, has been so carefully framed by the photographer that its utilitarian function has been completely lost. Instead, we are presented with an intriguing, two-dimensional abstract composition of colour and shape.

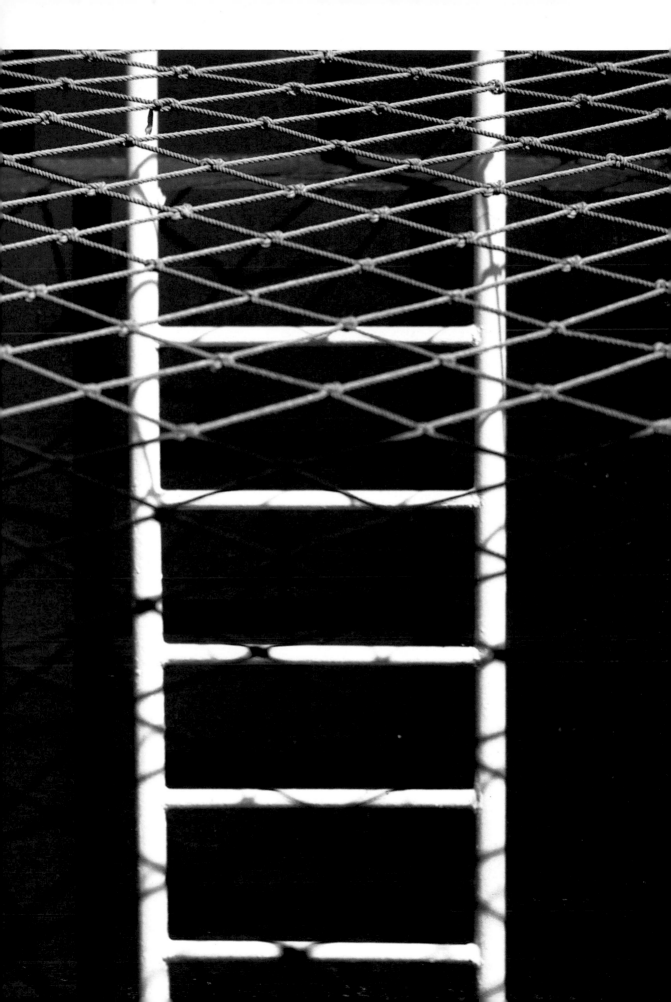

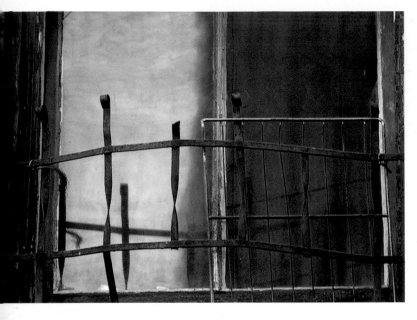

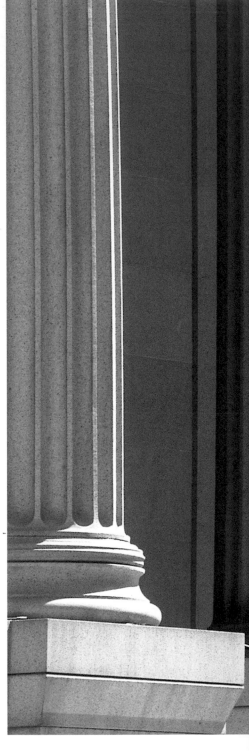

▲

PHOTOGRAPHER:
Paul Kirk
CAMERA:
35mm
LENS:
135mm
FILM:
ISO 64
EXPOSURE:
1/60 second at f5.6
LIGHTING:
Daylight only

When seen from one angle, this second-floor window revealed nothing of interest, just an opaque grey with faintly visible impressions of domestic clutter from the unlit interior. Just by walking a few feet more, however, the interior of the room dropped away and the glass became a mirror reflecting a distorted image of the ironwork in the immediate foreground and the colour of the building opposite.

▶

PHOTOGRAPHER:
Comstock/Mike Stuckey
CAMERA:
35mm
LENS:
85mm
FILM:
ISO 64
EXPOSURE:
1/125 second at f11
LIGHTING:
Daylight only

The way a frame of photographic colour emulsion records a scene is radically different to the way we perceive it with our eyes. If, for example, we view a piece of cloth we know to be white by coloured light, we discount the false colour and still see it as being white. Film cannot do this, as you can see in this shot, in which white marble columns are illuminated by daylight coming from an intensely blue sky above New York's Wall Street.

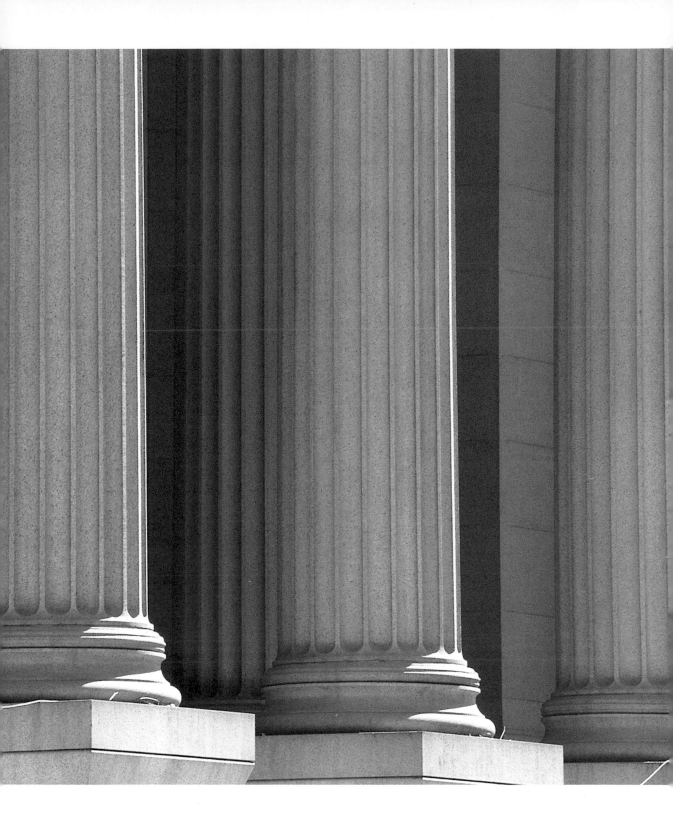

Reflections

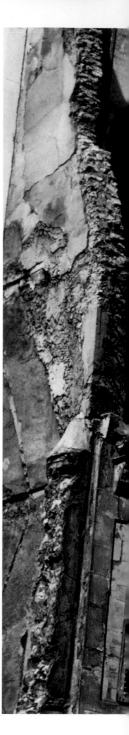

INSTEAD OF THE RATHER STUFFY image many people have of
architectural photography, there is in fact a host of imaginative
and creative ways to interpret the built environment that
surrounds most of us most of the time.

One of the problems associated with trying to photograph
an entire building is that often there is not enough clear space
surrounding it, with the result that you end up working far too
close with a wide-angle lens angled upward to ensure no part
of the structure is inadvertently omitted. And this, as most of
us know from personal experience, introduces a range of often
unsatisfactory perspective distortions. And even if you can
move far enough back, the building will probably then be too
small in the resulting picture to have much pictorial impact.

However, rather than attempting to include the entire
building it is often far better to look for just a part of the
structure that, when seen from a particular viewpoint, offers
the potential for a new and refreshing image. And with the
preponderance of the glass-and-steel edifices so beloved by
modern architects, you could find yourself literally surrounded
with reflected images of your subject, each offering you a
different slant on a traditional theme.

FOCUSING FOR REFLECTIONS

Although not really a problem for users of
reflex cameras, because they are able to
see the actual image in the viewfinder that
is produced by the lens, the point of focus
of a reflection is not at the surface from
which the image is reflected. For example,
if you were to stand 2m (6ft) in front of a
mirror, from a photographic point of view,
your reflection is not 2m (6ft) away, but
rather 4m (12ft). For focusing purposes,
the light has travelled 2m (6ft) from you to
the mirror and then the same distance
back again, and so you will need to focus
on a lens-to-subject distance of 4m (12ft).

With a reflex camera you can, of course,
see immediately on the focusing screen
when the image snaps into focus.

If, however, you want to record both
the reflecting surface and the reflection
sharply focused, you may need to set a
small aperture in order to maximize depth
of field. And if you are using a relatively
heavy, long focal length lens, the
compensating shutter speed to ensure
correct exposure may require you to use a
tripod, or some other form of camera
support, to overcome the problem of
camera movement.

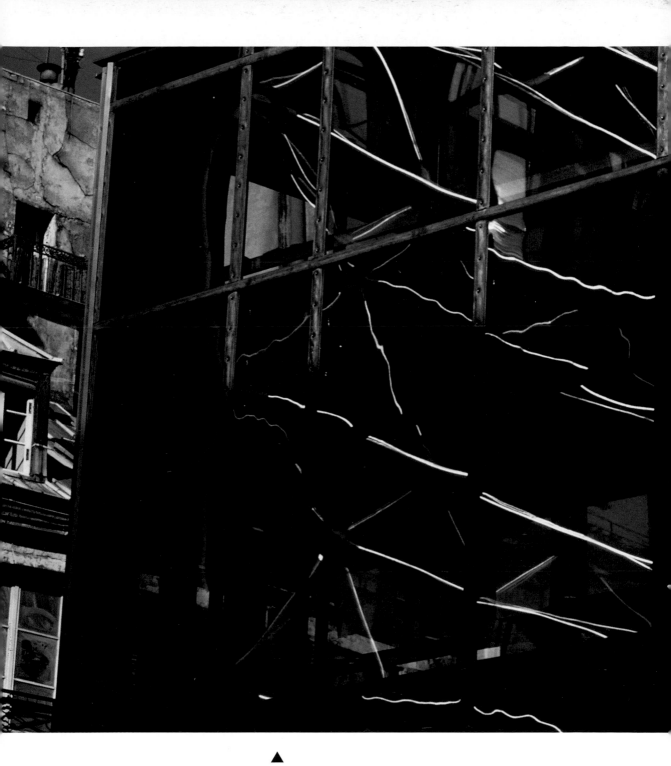

PHOTOGRAPHER: **Paul Kirk** CAMERA: **35mm** LENS: **185mm** FILM: **ISO 400**	EXPOSURE: **⅟₁₂₅ second** **at f11** LIGHTING: **Daylight only**

A long lens picking out just a tiny edge of the Pompidou Building in Paris has given us an image of stark architectural and visual contrasts. Reflecting both the neighbouring structures and the intense blue of the sky, the cultural vigour that the Pompidou Building symbolizes all but overpowers the crumbling façade of an earlier Paris that is fast being swept away.

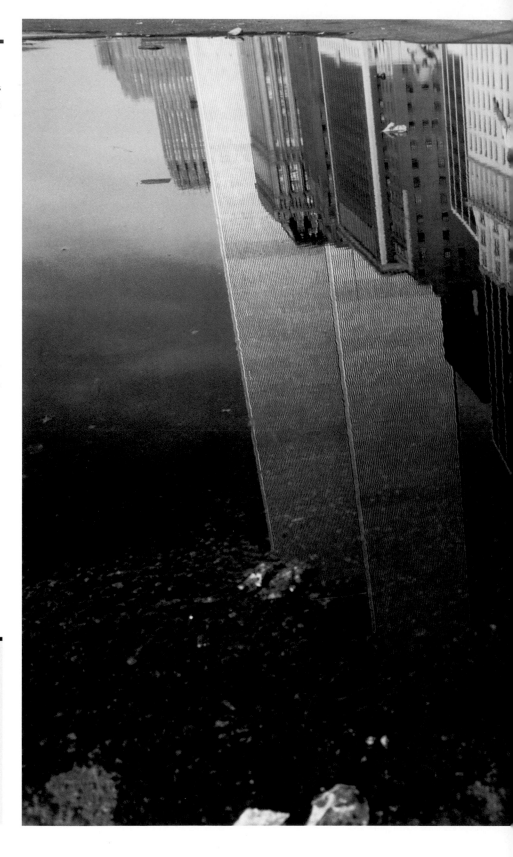

The potential for eye-catching photographs exists all around you, but you must remain receptive. Here, the photographer simply looked down at the road and there, at his feet, he found a near faultless reflection of New York's World Trade Center. By including the pedestrian and cyclist in the shot he has introduced a sense of scale and space, and by ensuring that at least some of the edges of the road surface can be seen, we are immediately informed that the reflecting surface is, indeed, just a shallow puddle.

PHOTOGRAPHER:
Paul Kirk
CAMERA:
35mm
LENS:
28mm
FILM:
ISO 400
EXPOSURE:
½₂₅₀ second at f8
LIGHTING:
Daylight only

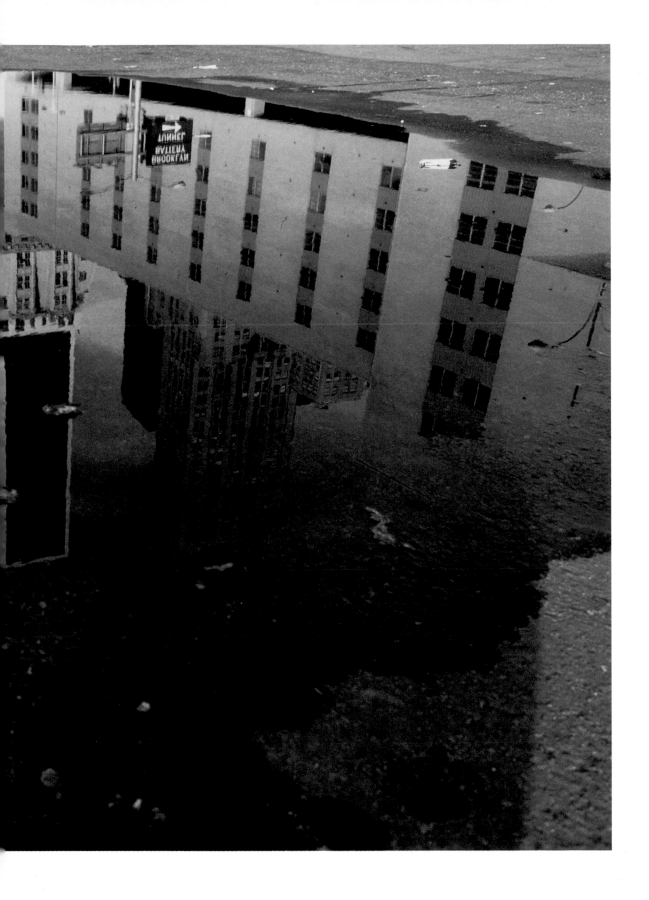

PHOTOGRAPHER:
Paul Kirk
CAMERA:
35mm
LENS:
90mm
FILM:
ISO 200
EXPOSURE:
1/60 second at f11
LIGHTING:
Daylight only

Store windows and highly polished signs can all be turned to your advantage when taking pictures of reflected images. Seen from one perspective, any reflective surface may appear dull and uninformative. Yet by changing your viewpoint just slightly, so that the light reaching the camera is reflecting back at a different angle, a whole world of imagery may be opened up. Large sheets of glass for shops fronts and buildings are rarely manufactured to produce a perfectly true reflection. And so, by shifting the camera up or down or from side to side, you will probably be able to see the reflected image undergoing a series of wavelike undulations. Use these effects by shifting your position until the distortion makes a useful shape or disappears completely, depending on the effect you want to achieve.

PHOTOGRAPHER:
Paul Kirk
CAMERA:
35mm
LENS:
90mm
FILM:
ISO 400
EXPOSURE:
1/250 second at f5.6
LIGHTING:
Daylight only

PHOTOGRAPHER:
Paul Kirk
CAMERA:
35mm
LENS:
**70–210mm zoom
(set at 70mm)**
FILM:
ISO 400
EXPOSURE:
1/60 second at f16
LIGHTING:
Daylight only

PHOTOGRAPHER:
Paul Kirk
CAMERA:
35mm
LENS:
**70–210mm zoom
(set at 180mm)**
FILM:
ISO 400
EXPOSURE:
1/125 second at f8
LIGHTING:
Daylight only

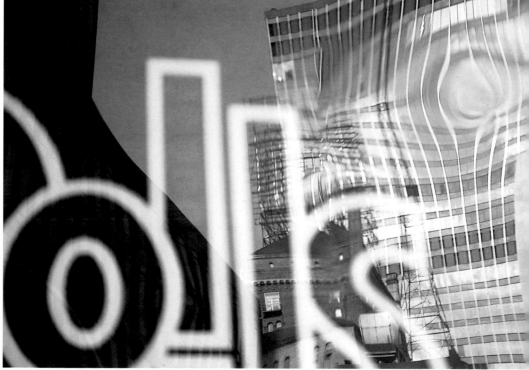

▶

Taken from inside behind a glass window, this image shows a series of internal reflections imposed on the outside view. The result is powerfully solid and geometric, full of square, rectangular and triangular shapes. These shapes appear strangely at odds with the move-ment created by the diagonal lines and soft, pastel shades of blue-grey and dusty pink.

PHOTOGRAPHER:
Comstock/Tom Grill
CAMERA:
6 x 7cm
LENS:
95mm
FILM:
ISO 50
EXPOSURE:
⅙₀ second at f16
LIGHTING:
Daylight only

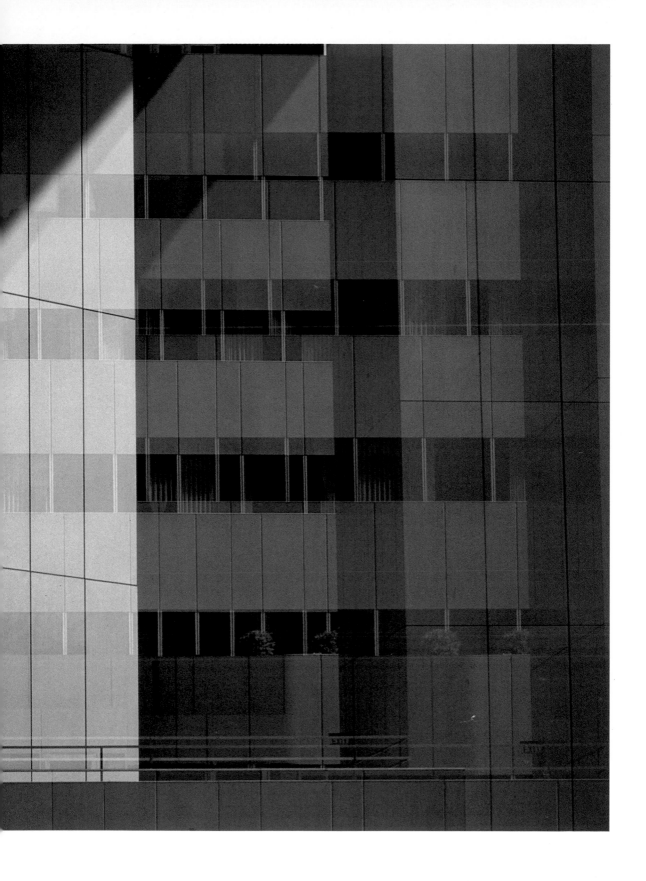

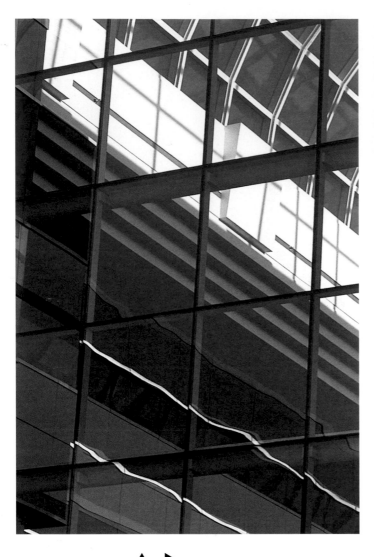

▲ ▶

PHOTOGRAPHER:
Comstock/
Tom Grill
CAMERA:
35mm
LENS:
135mm
FILM:
ISO 64
EXPOSURE:
½₅₀ second at f11
LIGHTING:
Daylight only

When the reflecting surfaces have, as you can see in the two images here, a strong, repeating pattern created by the individual panes making up the buildings' façades, you need to find exactly the right camera position so that the reflection and the surface pattern complement one another (right). If, on the other hand, they end up competing for the viewer's attention, the result will be weakened and have less impact (above).

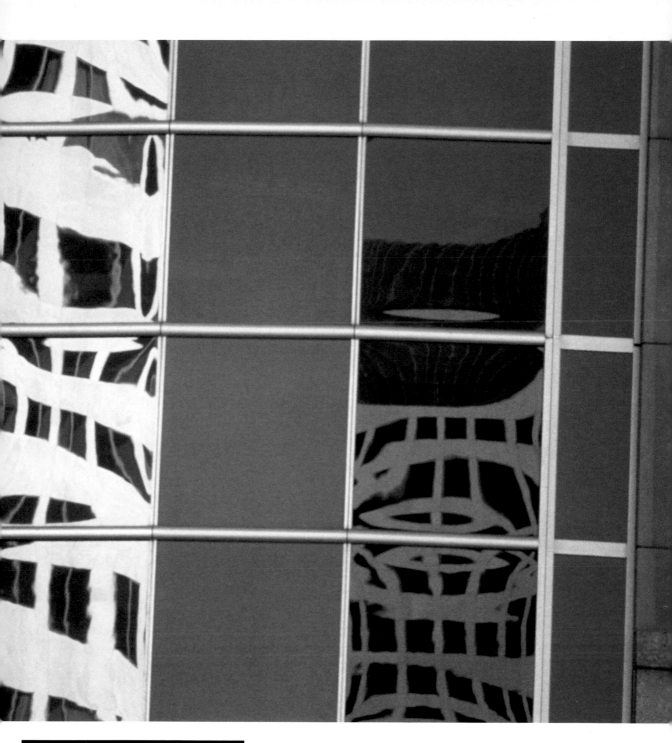

PHOTOGRAPHER:
Comstock/
Laura Elliott
CAMERA:
35mm
LENS:
180mm

FILM:
ISO 100
EXPOSURE:
⅓₀ second at f22
LIGHTING:
Daylight only

4

THE NATURAL WORLD

Winter wonder

IN THE MORE EXTREME LATITUDES, a stillness settles on the natural landscape during the winter months. Animals, plants and trees adopt different survival strategies, either becoming dormant or else reducing activity to the bare minimum to conserve energy until the days lengthen once more with the arrival of spring.

For photographers, the winter landscape can be a very different place from what they know at other times of year. Familiar colours are altered or reduced to monochromes, perhaps cloaked under a blanket of snow or ice. The very shapes of the landscape can alter, too – trees and shrubs stripped bare of their foliage leave only stark and structural outlines, creating new spaces that expose views, which, at

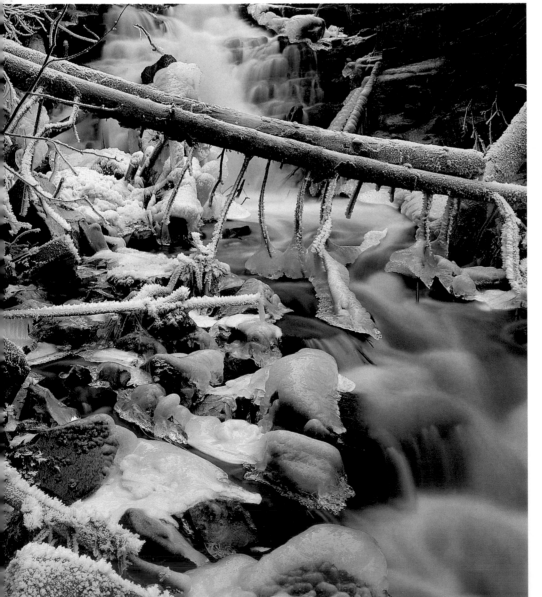

◀

Dramatically evocative of a northern winter scene, the light levels were so low at this time of year that an exposure of many seconds was needed. Exposure time was lengthened even further by the need to use a small lens aperture in order to maximize the depth of field.

PHOTOGRAPHER:
Bert Wiklund
CAMERA:
6 x 4.5cm
LENS:
80mm
FILM:
ISO 100
EXPOSURE:
9 seconds at f22
LIGHTING:
Daylight only

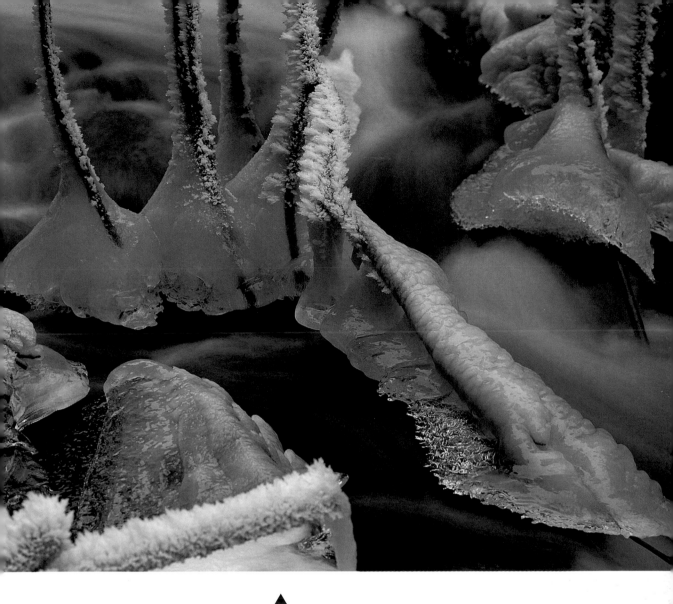

▲

other times of the year, are obscured. And it is this very starkness that attracts many photographers looking for more unusual landscape pictures, as well as close-up compositions.

It is only in intense cold that you need to take any special precautions with photographic equipment. In such conditions, the batteries powering the exposure meter, film advance, autofocus and other electric functions can be drained of power very rapidly, and the lubricating oil put in during manufacture to keep moving parts moving can freeze solid. If you are worried, take your equipment to a specialist and have it serviced for cold-weather use.

Moving in closer for a tighter view of the first scene, here the photographer has selected an area with strong foreground interest, composed principally of shape, form and texture, and has sacrificed the background entirely. Note the effect that the long exposure times have on the rapidly moving water, which has taken on a soft, smoky solidity with a truly magical quality.

PHOTOGRAPHER:
Bert Wiklund
CAMERA:
6 x 4.5cm
LENS:
80mm
FILM:
ISO 100
EXPOSURE:
9 seconds at f22
LIGHTING:
Daylight only

Images of summer

SUMMER IS A TIME OF EXUBERANCE in nature. It is can also be a time of extreme contrasts – not just of light, with intense highlights and impenetrable shadows created by a high, overhead sun, but also of scenery. In regions where the climate is gentle and the rains reliable, a profusion of foliage and flowers, with their attendant abundant insect life, is a typical image of the summer months, as well as a feast of opportunities for the alert photographer. In harsher regions, however, the intense heat of summer can scorch the surface of the earth clean of all life, leaving nothing behind but a cracked and sterile lunar-like landscape.

Summer can also be a time of rapidly changing weather conditions. Summer storms can bubble up from nowhere in what seems to be just seconds, deluging the land and then evaporating just as quickly. Don't take this as a cue to head for shelter, though, for it is exactly these unpredictable changes in lighting quality and intensity that often produce the most inspired of images.

▶

PHOTOGRAPHING THE SUN

- Take particular care whenever the disc of the sun appears in the viewfinder, since even a weak, low sun can cause damage to the retina of the eye. This is particularly true when using a telephoto lens. Try not to look directly at the disc and, if possible, attach a neutral density filter to the lens while you compose the image. This type of filter cuts down the intensity of light entering the lens without affecting colour balance, and so it can be left on for the exposure as long as you can still use an appropriate combination of shutter speed and lens aperture.

- When the disc of the sun is not in the frame, flare can still cause image-recording problems unless you use a lens hood or shade the front element of the lens with your cupped hand.

- Bear in mind that some exposure meters can become 'overloaded' if exposed to brilliant sunlight for too long a period. Switch the meter off while composing your shot, and switch it back on briefly just prior to making the exposure.

Viewed through a 600mm lens, the perfect disc of the sun as it sinks towards the horizon appears huge in the frame. Even though this picture was taken just minutes before sundown, the photographer used a neutral density filter on the lens as a safety precaution.

PHOTOGRAPHER:	FILM:
Comstock/	ISO 50
Hartman DeWitt	EXPOSURE:
CAMERA:	⅟₆₀₀ second at f4
35mm	LIGHTING:
LENS:	Daylight only
600mm	

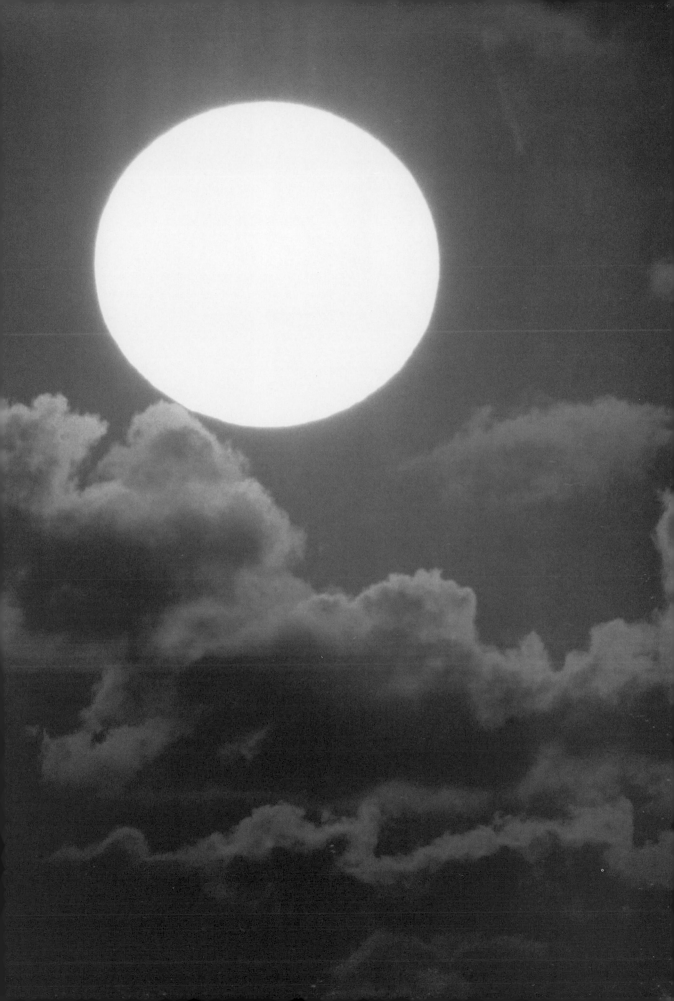

▲

Months of unrelenting heat, and rains that never fell, have reduced this landscape to a pattern of barren cracks and fissures. Coming in close with the camera to concentrate on just a part of the scene emphasizes the tragedy of the situation through such subject elements as pattern, shape and colour.

PHOTOGRAPHER:
**Comstock/
Mike Stuckey**
CAMERA:
6 x 7cm
LENS:
90mm
FILM:
ISO 100
EXPOSURE:
**½₅₀ second
at f16**
LIGHTING:
Daylight only

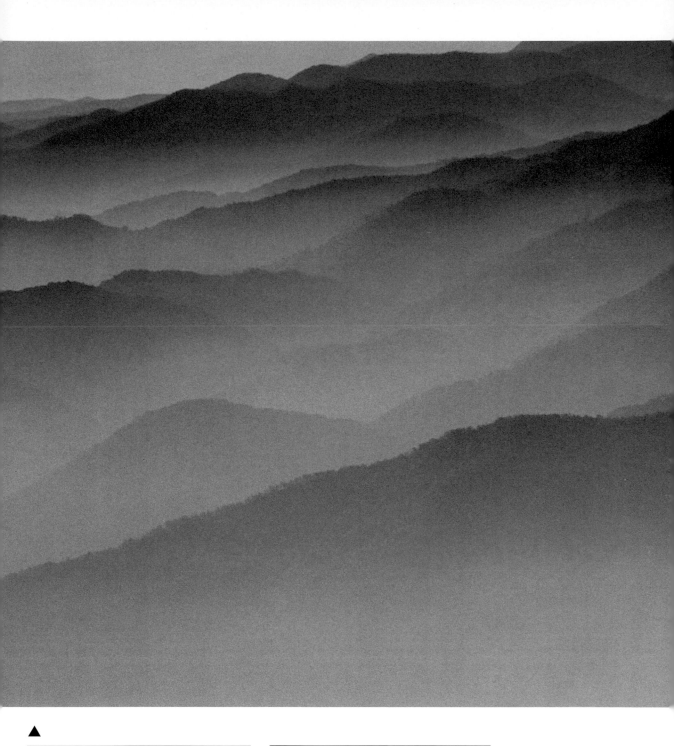

▲

Viewed from high up on a cliff-top, the clouds have taken on the appearance of rolling mountain ranges, not unlike those out of sight below. Note the appearance of aerial perspective in the picture, evident in the colour shift towards blue as you look towards the distant horizon. Ultraviolet (UV) light is responsible for this, and its presence can be minimized by using a UV lens filter.

PHOTOGRAPHER:	FILM:
Comstock/Tom Grill	**ISO 100**
CAMERA:	EXPOSURE:
6 x 4.5cm	**1/125 second at f8**
LENS:	LIGHTING:
50mm	**Daylight only**

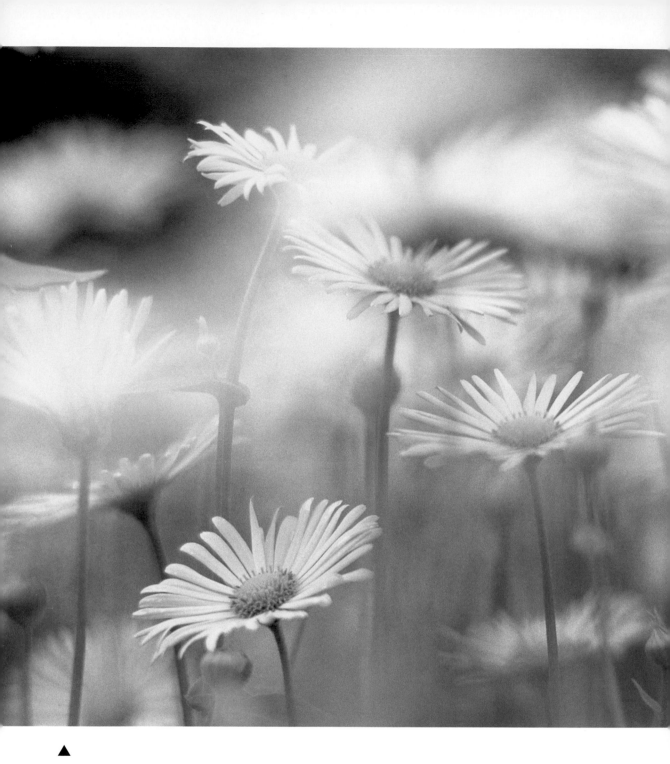

▲

The joyful yellow of these perfect blooms recalls sunshine and gentle rain. This lush profusion of colour makes you imagine that if you were to breathe in deeply you could smell the scent of flowers and meadow freshness. The background blurriness of the image is the result of the shallow depth of field associated with close-ups taken at wide apertures, and to achieve the foreground smearing of the image, the photographer applied random patches of petroleum jelly to a clear-glass lens filter.

PHOTOGRAPHER:	FILM:
Comstock/Tom Grill	**ISO 64**
CAMERA:	EXPOSURE:
35mm	**¹⁄₁₂₅ second at f8**
LENS:	LIGHTING:
28–70mm zoom (set to macro mode)	**Daylight only**

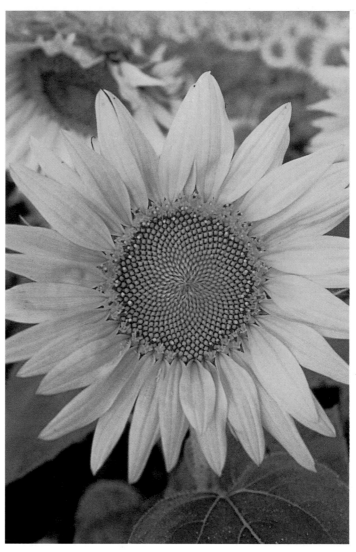

▲

Neat ranks of sunflowers, grown commercially for their oil content and seeds, are a common sight in summer in some areas. By moving in close to a single foreground flower-head and using a wide-angle lens, the photographer has created an eye-catching perspective. The colour contrast between the yellow of the heads and green of the leaves is compelling.

PHOTOGRAPHER:
Comstock/
Mike Stuckey
CAMERA:
35mm
LENS:
28mm
FILM:
ISO 100
EXPOSURE:
1⁄250 second at f4
LIGHTING:
Daylight only

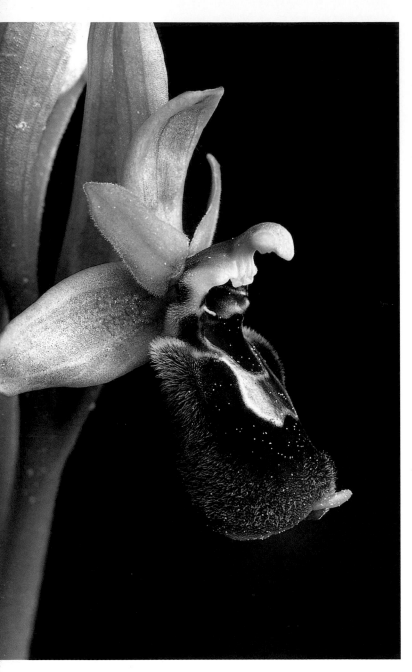

▲

The colours, shapes and textures of complex blooms, such as this orchid, take on an almost alien appearance when viewed in close-up.

PHOTOGRAPHER:
Bert Wiklund
CAMERA:
35mm
LENS:
55mm macro
FILM:
ISO 50
EXPOSURE:
1/30 second at f11
LIGHTING:
Daylight only

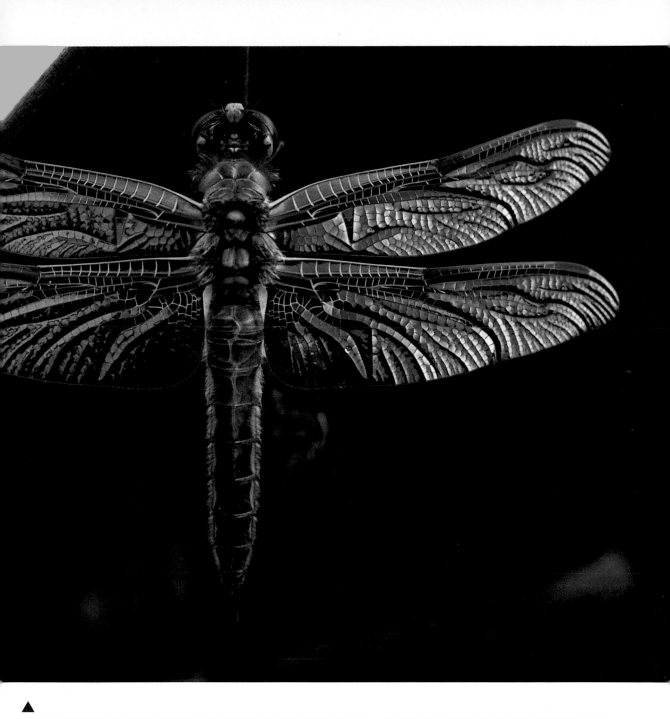

▲

The dragonfly is a common sight hovering around reedy ponds or larger bodies of water during the summer months. Although not particularly shy, they prefer to keep a healthy distance between themselves and people. To take this shot, the photographer set up the camera on a tripod, with the lens prefocused on a spot where this particular dragon fly had paused to rest many times in the past. When the insect was judged to be in the correct position, the shutter was tripped using a long cable release. Many species of dragonfly are large enough to be photographed without using specialized equipment.

PHOTOGRAPHER:	FILM:
Bert Wiklund	**ISO 50**
CAMERA:	EXPOSURE:
35mm	**⅟₆₀ second at f16**
LENS:	LIGHTING:
55mm macro	**Daylight only**

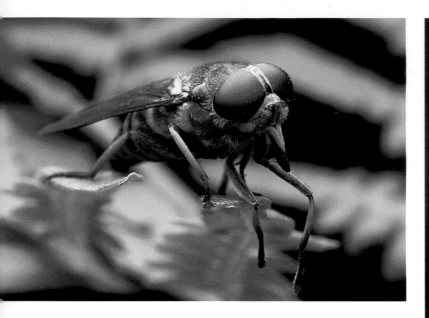

▲ ▶

PHOTOGRAPHER:
Bert Wiklund
CAMERA:
35mm
LENS:
**28–70mm zoom
(set to macro
mode)**
FILM:
ISO 100
EXPOSURE:
**⅟₆₀ second at
f11 (bee)
⅟₆₀ second at
f16 (wasp)**
LIGHTING:
Daylight only

For the natural history photographer working outdoors in the garden or further afield on location, the summer months can be the most productive time of year. Not only do the numbers of insects peak during the summer, in response to plentiful supplies of such food as flower pollen, light levels should also be at their highest, which can be crucial when you are working very close to a small subject, such as this bumble bee (right) or wasp (above). Choose your camera position carefully – it is very easy for some part of your equipment (even a wayward camera strap) or you yourself or your clothing, if loose-fitting, to momentarily cast a shadow over the subject or its immediate surroundings and spoil the shot.

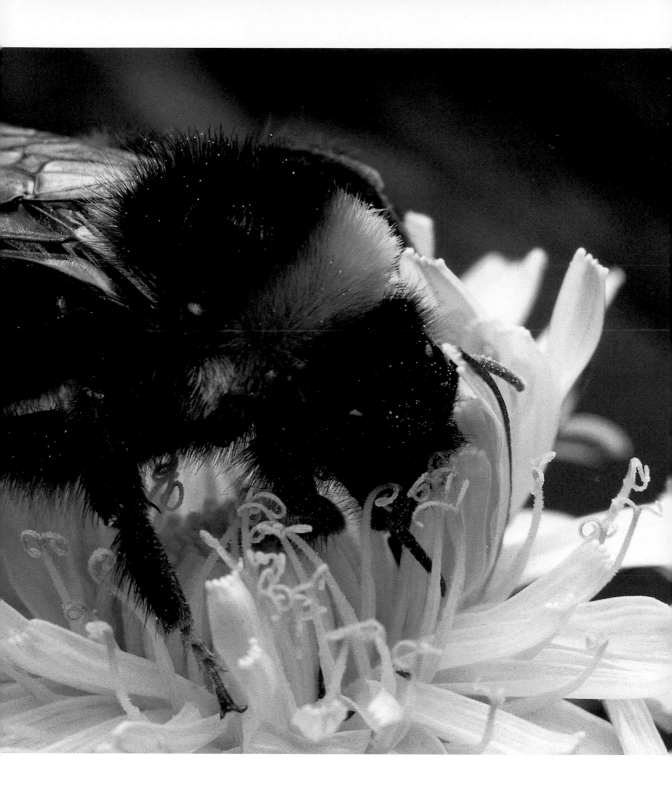

Leaf-fall

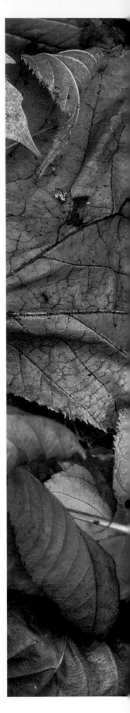

Once you move away from the tropics and sub-tropics and into the more temperate regions of the world, seasonal changes become more marked. Rather than just wet or dry, which is the primary seasonal distinction in equatorial regions, the lower angle of the sun further north or south ensures that you experience the full range of seasons – winter, spring, summer and autumn.

Nowhere are the seasons more distinct than in temperate deciduous woodland. In response to the declining light levels of autumn, and the prospect of cold and frozen earth soon to come when ground water will be locked up and unavailable, deciduous trees begin to withdraw nutrients from their leaves, allowing them to wither and then fall. For a few weeks of the year, these woodlands are ablaze with the golds, russets, browns and reds of decay – a decay, however, that ensures the continuation of the cycle of renewal. And when the trees are bare, although the daylight hours are briefer than at other times of the year, there is then little to obstruct the available light filtering through to the carpet of colour, and the wealth of photographic opportunities, on the ground beneath.

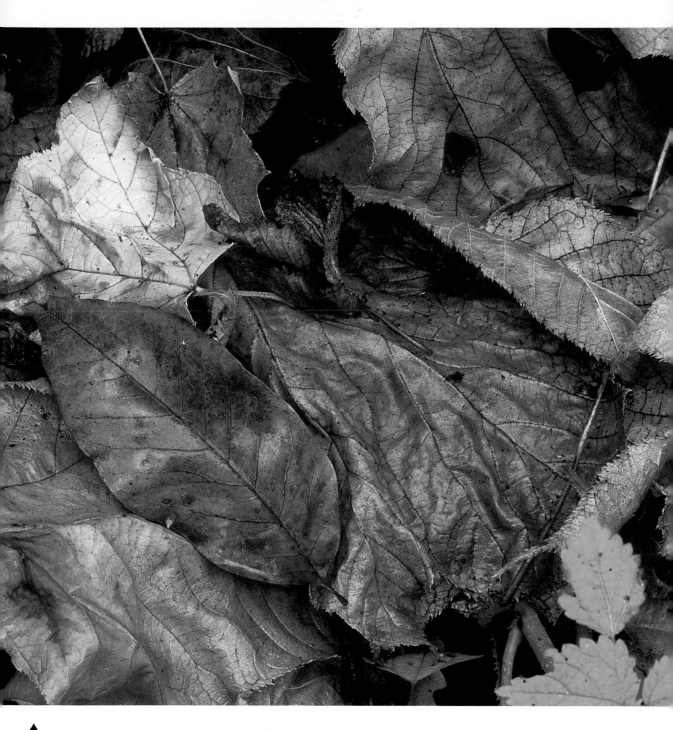

One of the advantages of close-up photography is that you can 'extract' a potential composition from just part of an unpromising subject. This image of autumn leaves came about after a tidying-up session in an ordinary suburban garden. After raking the leaf litter together from different parts of the garden, the photographer's eye was attracted to just a small section of the resulting mound, where a combination of colour, shape and form demanded the attention of his camera.

PHOTOGRAPHER:	FILM:
Comstock/Henry Georgi	**ISO 100**
CAMERA:	EXPOSURE:
6 x 7cm	**⅟₆₀ second at f5.6**
LENS:	LIGHTING:
80mm	**Daylight only**

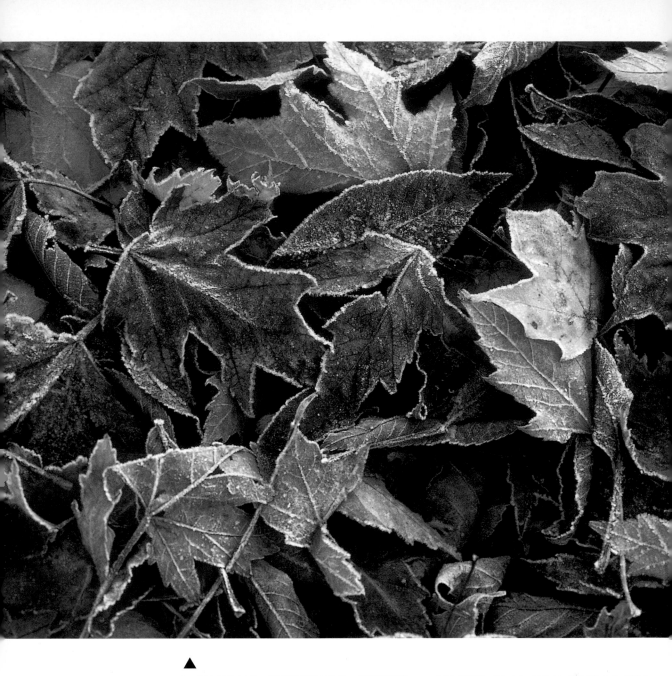

▲

Later in the season as autumn progresses, the different colours of the leaf litter tend to merge to create more monochromatic compositions, as here, where each individual leaf is fringed with white from the previous evening's frost.

PHOTOGRAPHER:
Comstock/Gwen Fidler
CAMERA:
6 x 7cm
LENS:
105mm

FILM:
ISO 50
EXPOSURE:
⅓₀ second at f11
LIGHTING:
Daylight only

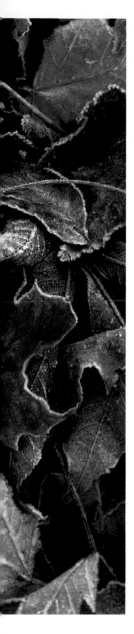

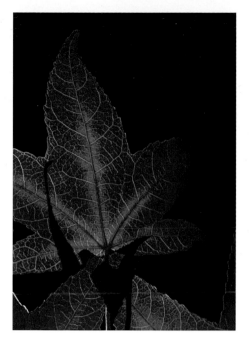

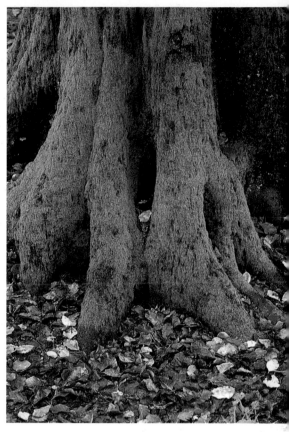

▲

Choosing a camera viewpoint so that the sun itself is masked by the overhead subject might ordinarily produce a silhouette. Here, however, the leaves have thinned down as part of their dying process and have taken on a translucency that allows the light to glow through their structure to create a firelight effect.

PHOTOGRAPHER:
**Comstock/
Tom Grill**
CAMERA:
35mm
LENS:
180mm
FILM:
ISO 200
EXPOSURE:
½₅₀ second at f11
LIGHTING:
Daylight only

▲

A wider view of this forest scene would have revealed a series of moss-covered tree trunks emerging from an unbroken carpet of leaves. Such a composition would have revealed strong colour repetition in the blocks of green, which, the photographer determined would have taken the viewer's eyes through the scene to a distant hill and the sky beyond. By choosing to take a close-up shot instead, our focus has been narrowed and our concentration confined to a detail, one rendered so accurately that it is possible to imagine exactly what the moss would feel like if you could reach into the frame and touch it.

PHOTOGRAPHER:	FILM:
Bert Wiklund	**ISO 100**
CAMERA:	EXPOSURE:
6 x 4.5cm	**½₂₅ second at f11**
LENS:	LIGHTING:
80mm	**Daylight only**

Animal subjects

ONE OF THE PERENNIAL PROBLEMS facing the wildlife photographer is how to get close enough to their subjects – either physically or by using the appropriate lens – to obtain a good-sized image in the camera's viewfinder. In safari and wildlife parks, regular animal residents become so accustomed to the presence of vehicles that they take little or no notice of them, even coming over to rest in the shade cast by cars or tourist buses. In this type of situation, close-ups are not too much of a problem, but you have to ensure that your framing – taking in the background and more immediate surroundings – doesn't include parts of other tourist vehicles (or their shadows), litter or anything else that gives a clue that the animals were not photographed in an entirely natural setting.

Truly free and wild animals, such as those living in vast game parks or wilderness areas, present very different problems, for unless you know something of your subjects' behaviour and likely movements you could spend days and days and come up with nothing at all to show for your effort. Even if you know where to look, you will probably still have to stay far enough away to make photography with anything other than an extreme telephoto a waste of time, since the resulting image will be too small in the viewfinder. Selective enlargement of the resulting print or slide is possible, but bear in mind that the degree of enlargement the film original will be subjected to is likely to produce a soft and grainy result.

TELEPHOTOS AND LENS SPEED

The speed of a lens refers to its widest maximum aperture – the wider the aperture offered, the faster the lens. Fast lenses not only allow you to take pictures in dimmer lighting conditions, they also produce a brighter viewfinder image, which is vital when critical focusing is required. The problem with telephotos in general, and extreme telephotos in particular, is that you are likely to have a widest maximum aperture of only about f5.6 or f8 – in comparison, with a standard 50mm lens (on the 35mm camera format), a maximum aperture of f1.4 is not unusual. The depth of field on, say, a 500mm lens at f8 is extremely shallow and leaves little scope for focusing errors. Autofocus lenses can be useful, but you need to ensure that (depending on type) you position your subject in the focusing target area of the frame (usually the centre). Then you must focus, lock the setting and recompose the image, if necessary, before shooting. You can become quick at this, but wildlife photography often means grabbing quick shots as and when subject opportunities present themselves, and manual focusing for off-centre or more 'unusual' compositions can be quicker. Wildlife photographers often set the camera controls in advance anyway, prefocusing on the likely area the animal will appear in, and so autofocus becomes less than useful in situations such as this.

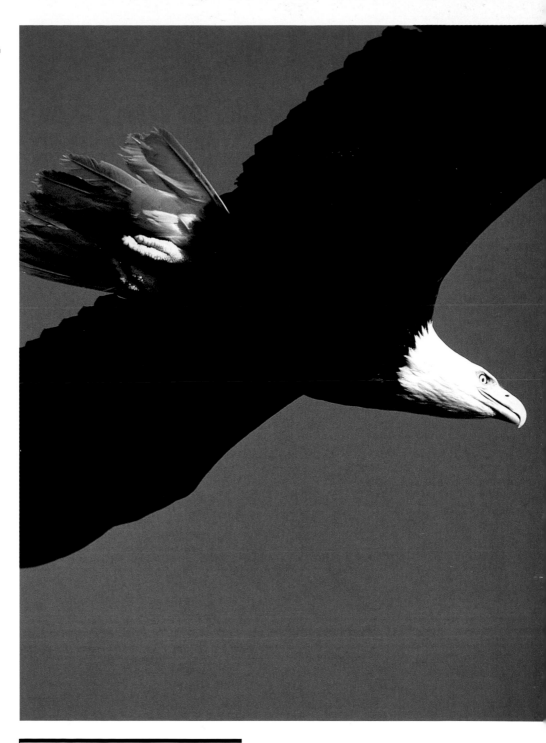

This soaring giant, the bald eagle, is a magnificent sight, and where better to photograph it than in its natural habitat – the sky. Eagles, like many birds, minimize flapping their wings whenever they can in order to conserve energy. So, to gain height, they search for convenient thermal currents, open their wings and simply ride the current upwards. If you know the terrain you are working in, or have an experienced guide to advise you, you will know where regular thermals can be found. And it is at just such a place that the photographer set up his camera and waited for an eagle to come within range of his camera lens.

PHOTOGRAPHER: **Comstock/** **Denner Bryan**	FILM: **ISO 100**
CAMERA: **6 x 7cm**	EXPOSURE: **½₅₀ second at f8**
LENS: **350mm**	LIGHTING: **Daylight only**

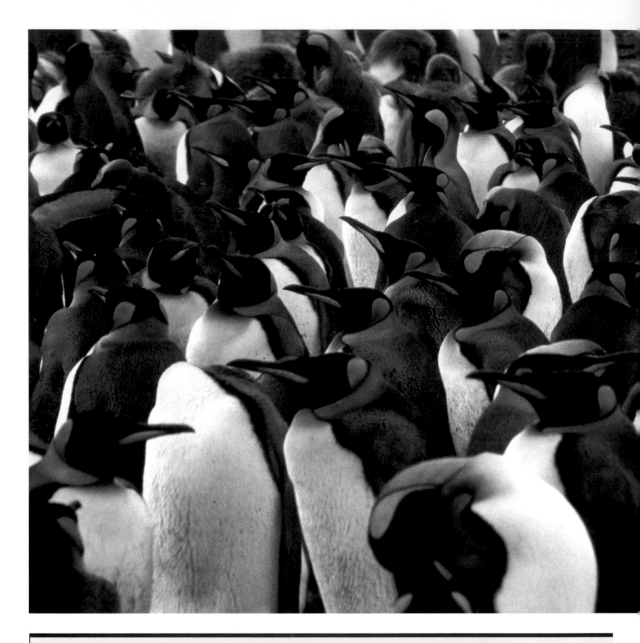

KEEPING THE LENS STEADY

Telephoto lenses are far heavier than standard or wide-angle optics and because of the degree of subject enlargement they produce, even the smallest amount of camera shake will result in unacceptably blurred images. The best way to support a long lens is on a sturdy tripod. These even when folded up, however, are bulky and heavy to carry for any distance. Light-weight models are available, but these are not necessarily stable and are prone to toppling over. Whatever tripod you choose, make sure that it is has a good-quality, free-moving pan-and-tilt head.

If a tripod is not a practicable proposition, consider using a monopod. Although not as stable as even a lightweight tripod, a monopod will take the weight of the lens, leaving you with both hands free to concentrate on steadying the camera before shooting. Monopods telescope into a very compact size that can easily be slipped into a camera bag.

Another alternative is a type of camera support known as a rifle grip, so called because once the camera and lens are fitted, you raise and hold it into your shoulder for support, much as you would a rifle. If all else fails, look for any solid surface you can turn into an improvized support – a low wall, for example, or the window-sill of a car (with the engine turned off to prevent vibrations).

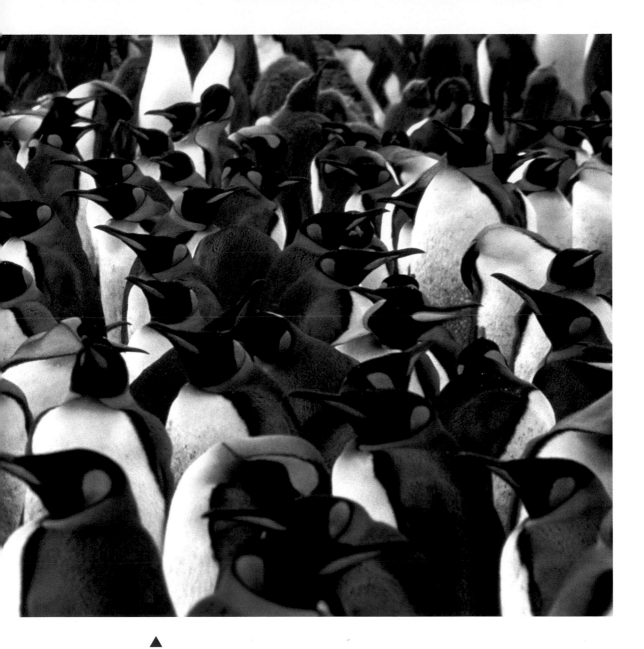

▲

PHOTOGRAPHER:
**Comstock/Sharon
Chester**
CAMERA:
6 x 7cm
LENS:
300mm
FILM:
ISO 50
EXPOSURE:
**1/25 second
at f11**
LIGHTING:
Daylight only

Many factors make up what we perceive to be a successful photograph, such as this one of colony of king penguins. The subject matter is, of course, instantly appealing to most people, who harbour an amused affection for penguins because of their slightly drunken, dinner-jacketed appearance. Equally, this photograph could have appeared earlier in this book, in the section dealing with shape or the one dealing with pattern. Although penguin colonies can be surprisingly tolerant of human intrusion, in this case the photographer chose instead to remain outside their nesting area and to use a long lens to take a close-up image of just some of the birds because of the presence of chicks in the background.

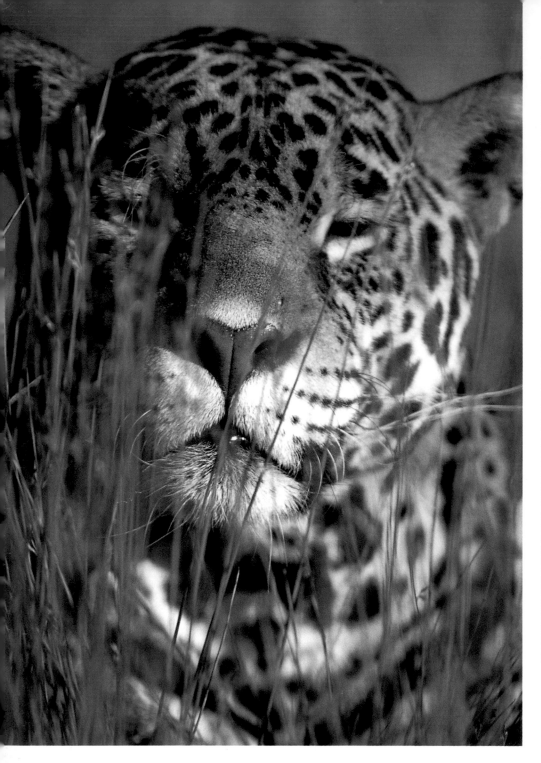

◄

The only way to approach a cat such as this is with extreme caution. Taken in the wild in a game park, this female jaguar was in prime condition and she was potentially very dangerous. In the company of a park ranger, the photographer spent three un-comfortable days in a hide that had been established months before within the cat's territory. Fortun-ately, cats have a reasonably predictable routine as well as their favourite sunning and hunting areas, and this, the ranger assured the photographer, would result in a successful shot – eventually.

PHOTOGRAPHER:	FILM:
Comstock/	**ISO 100**
Tom Grill	EXPOSURE:
CAMERA:	**¹⁄₂₅ second at f11**
35mm	LIGHTING:
LENS:	**Daylight only**
600mm	

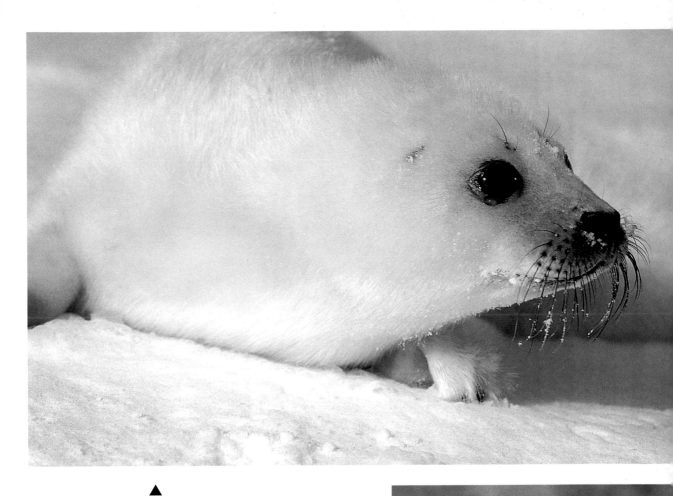

▲

PHOTOGRAPHER:
**Comstock/
Art Gingert**
CAMERA:
35mm
LENS:
90mm
FILM:
ISO 50
EXPOSURE:
⅟₂₅ second at f8
LIGHTING:
Daylight only

Full of milk and quite calm, coated in layers of blubber and topped off with a thermal insulation of dense fur, this seal pup was distracted by the photographer's companion while its picture was taken in profile. Be careful when taking a light reading in a snowy or icy setting, since the surrounding will probably be reflecting more light than the subject, and this can lead to underexposure.

▶

PHOTOGRAPHER:
**Comstock/
Franklin Viola**
CAMERA:
35mm
LENS:
600mm
FILM:
ISO 100
EXPOSURE:
**⅟₂₅ second
at f11**
LIGHTING:
Daylight only

Looking every inch a left-over from the days of the dinosaurs, this Cayman Island iguana, although keeping a wary eye on the photographer, posed, stock-still, for many minutes as the warmth of the day seeped into its thick, scaly hide.

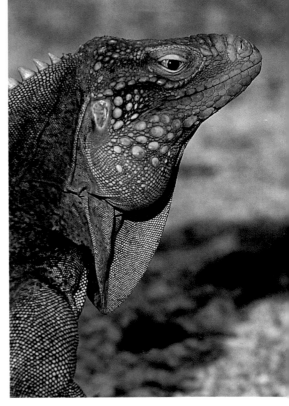

135

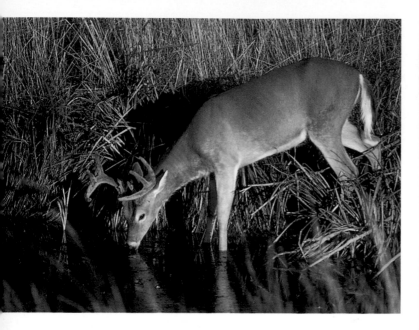

▲

PHOTOGRAPHER:
**Comstock/Denner
Bryan**
CAMERA:
35mm
LENS:
400mm
FILM:
ISO 50
EXPOSURE:
**1/250 second
at f16**
LIGHTING:
Daylight only

The warm glow of late afternoon sunlight was the perfect illumination for this shot of a drinking deer. Nearly all animals centre their lives around the ready availability of water, and so staking out a watering hole often pays dividends. A good time to plan a wildlife photography trip is in the dry season of the country you intend to visit, since then any permanent water should have a high concentration of animal visitors.

PHOTOGRAPHER:
**Comstock/
Russ Kinne**
CAMERA:
6 x 4.5cm
LENS:
180mm

FILM:
ISO 100
EXPOSURE:
1/125 second at f8
LIGHTING:
**Diffused accessory
flash**

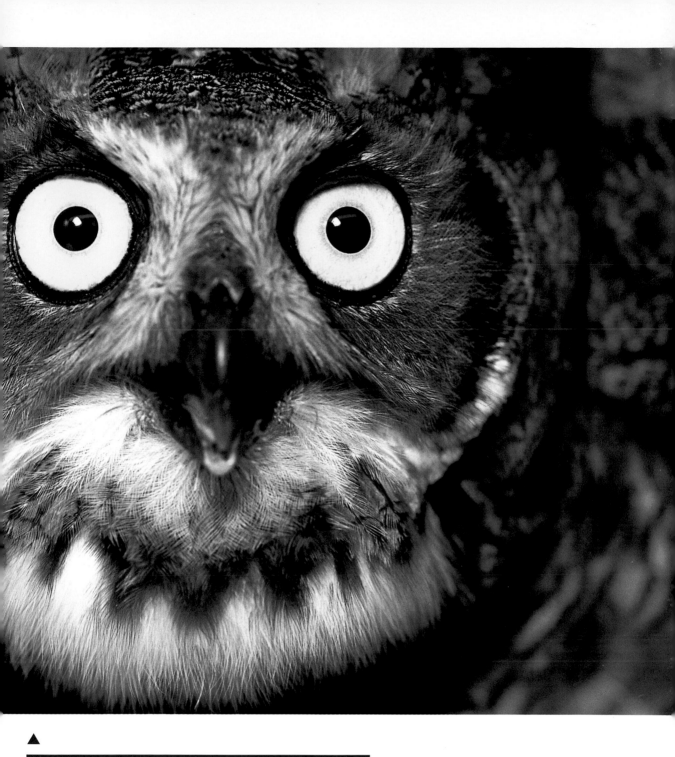

▲

Extreme close-ups of relatively large subjects, such as this fully-fledged young owl, have a huge impact and can be achieved without using specialized optics, such as you would need for dealing with much smaller subjects. However, other specialized equipment was required – a remote-controlled shutter release attached to a camera set up close to the nesting site, and activated by an infrared trigger that is tripped by the subject moving into the trigger's target area. In effect, the owl took its own photograph. The duration of the flash is so brief that animals often seem to fail to react to it.

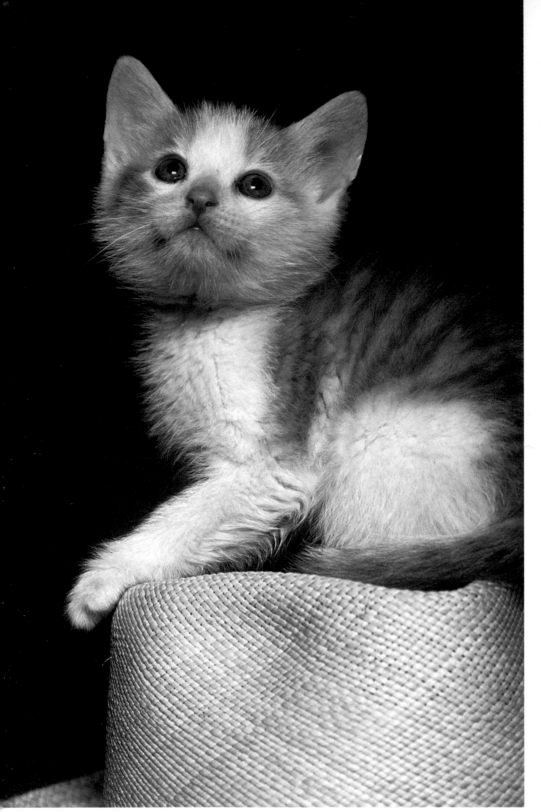

A young kitten such as this will not stay still for the camera very long unless it is asleep. Here, the photographer's assistant placed the young animal on the prepared set, on top of a sympathetically coloured straw hat, and then stood just out of view of the lens and encouraged it to look upwards. To ensure completely dark surroundings, the background was a piece of matt-black paper, positioned well back so that it would not catch any light spilling past the subject.

PHOTOGRAPHER:
**Comstock/
Robert Digiacomo**
CAMERA:
6 x 4.5cm
LENS:
150mm
FILM:
ISO 50
EXPOSURE:
1/60 second at f16
LIGHTING:
**Studio flash x 2
(1 fitted with barn
doors)**

Close-ups of family pets are a lot easier to achieve than similar pictures of wild animals. Unless you are taking a quick, opportunistic shot, take time to ensure that your pet will be seen against an uncluttered background and in a setting that complements its colouring. Dogs, such as this golden Labrador, which are accustomed to sleeping in a special space and on a familiar blanket make the task easier, since you can set up your lights and position the camera before encouraging the animal into over.

PHOTOGRAPHER:
**Comstock/
Mike Stuckey**
CAMERA:
6 x 4.5cm
LENS:
105mm
FILM:
ISO 100
EXPOSURE:
⅟₆₀ second at f5.6
LIGHTING:
**Studio flash
and diffuser**

5

PORTFOLIO

Alf Dietrich

With an international reputation now for creative and imaginative, technically superb food and still-life photography, as a young boy Alf Dietrich originally wanted to be a circus clown (father horrified), a little later a sailor (mother horrified), then a farmer (land impossibly expensive in his native Switzerland). Finally, he settled on becoming a photographer and has, since 1968, been working with his wife, Barbara, who is an excellent cook and food stylist in her own right.

Talking from his professionally kitted-out studio in Zurich, Alf explains about his approach to his work. 'Certainly, having the right equipment is important for my type of photography. But I never lose sight of the fact that the equipment is merely a tool. I take time to master it, learn how it works inside out, but never let myself be dominated by it. The implication of this approach is that I only use a piece of equipment if it is absolutely necessary to allow me to realize a particular image. In nearly every case, less invariably means more.'

Photographers working in an intensely commercial arena, one in which their work has to communicate a very precise message to a highly targeted audience, understanding the needs of the client and the way the final image will be used is vitally important to the success of that message. 'The ideal client knows exactly what he wants to achieve, who is being addressed by the photograph, what response each image should evoke. For this to happen, I invariably work as part of a team, liaising closely with the client's, or more likely the advertising agency's, art director and copywriter. Once the idea underlying the photograph has been defined, there follows a stage of the procedure that I find particularly fascinating, in which a complex idea is broken down into its component parts, each representing its own technical problem that needs to be solved. Only after this stage, when each of the technical aspects have been considered, discussed and resolved to everybody's satisfaction, can the complete concept be brought together in front of the camera. The rest is relatively easy and straightforward.'

'Unfortunately, these days many clients approach me with fully developed layouts based on ideas that have already been seen time after time. Carrying this type of commission through then becomes a mechanical process, an artistically unsatisfactory reiteration of a tired concept. I find that better work results when the client comes to me with a mind open to new ideas and suggestions, with roughly scribbled concepts rather than fully developed artwork boards. Only this way do I find that I can push the boundaries of my work forward in a technically and creatively challenging environment.'

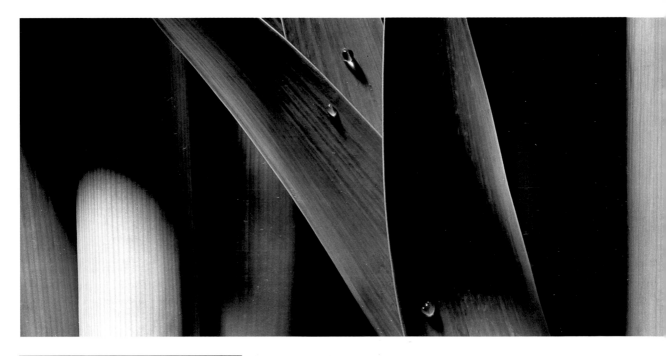

CLIENT:	CAMERA:
Coop Switzerland	**4 x 5in**
APPLICATION:	LENS:
Paper carrier bags for food department	**300mm macro**
	LIGHTING:
	Flash

143

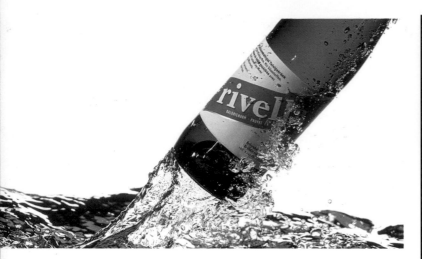

CLIENT:
Rivella AG (soft drinks)

APPLICATION:
Advertising poster

CAMERA:
4 x 5in

LENS:
300mm

LIGHTING:
High-speed flash ($\frac{1}{8000}$ second)

SPECIAL EFFECTS:
Flash fired by infrared trigger

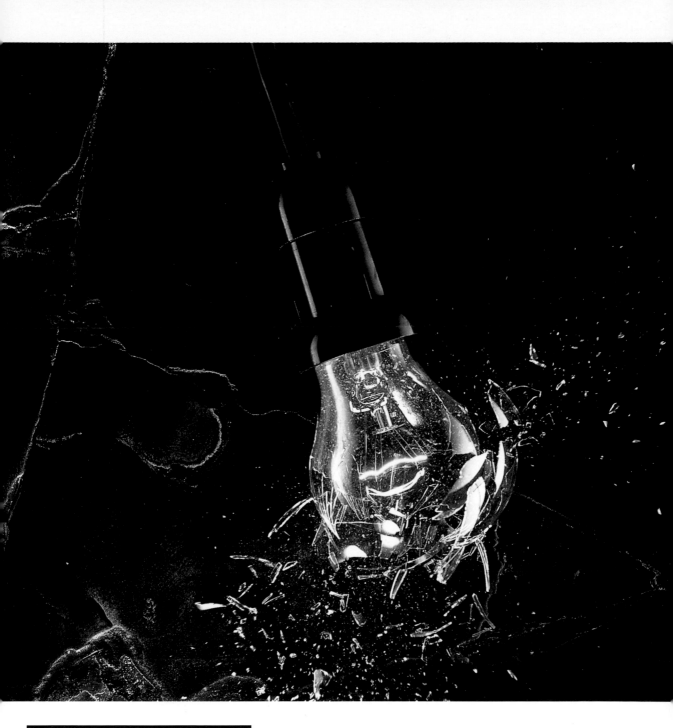

CLIENT:	LIGHTING:
None (self-promotion)	**High-speed flash (1/8000 second) and tungsten**
CAMERA:	
4 x 5in	SPECIAL EFFECTS:
LENS:	**Flash fired by infrared trigger**
300mm	

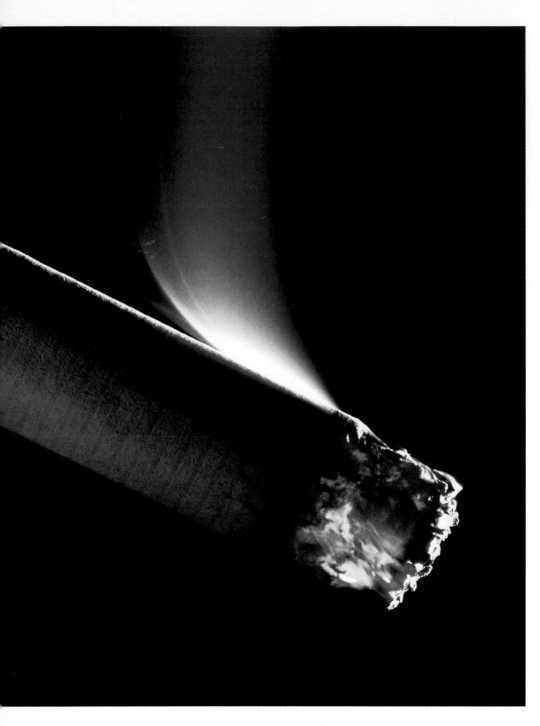

CLIENT:
Givaudan-Roure
SA (flavour
manufacturer)
APPLICATION:
Leaflet (flavours
for tobacco goods)
CAMERA:
6 x 6cm
LENS:
120mm macro
(plus extension
tubes)
LIGHTING:
Flash and available
light
SPECIAL EFFECTS:
Flash used for the
cigarette tube and
smoke; time-
exposure to record
the glowing tip

CLIENT:
Enka AG (stain
remover)
APPLICATION:
Series of posters
CAMERA:
4 x 5in
LENS:
300mm
LIGHING:
High-speed flash
($\frac{1}{8000}$ second)
SPECIAL EFFECTS:
Ketchup forced
out of bottle by
compressed air

CLIENT:	CAMERA:
Givaudan-Roure SA (flavour manufacturer)	4 x 5in
	LENS:
	300mm
APPLICATION:	LIGHTING:
Leaflet (flavours for pharmaceuticals)	Flash

CLIENT:	CAMERA:
Givaudan-Roure SA (flavour manufacturer)	6 x 6cm
	LENS:
	120mm macro (plus extension tubes)
APPLICATION:	LIGHTING:
Leaflet (flavours for dessert products)	Flash (reflected by mirrors)

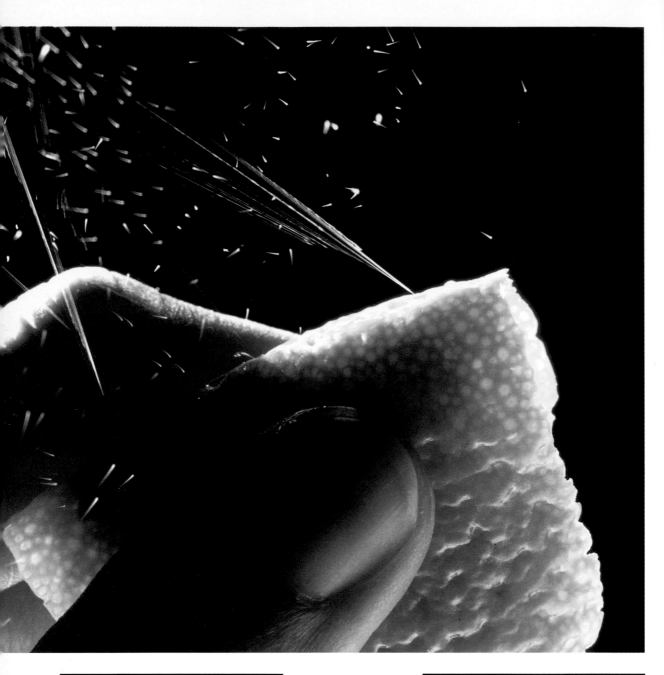

CLIENT:
Givaudan-Roure SA (flavour manufacturer)
APPLICATION:
Leaflet (citrus flavours)

CAMERA:
6 x 6cm
LENS:
120mm macro (plus extension tubes)
LIGHTING:
High-speed flash

CLIENT:
Givaudan-Roure SA (flavour manufacturer)
APPLICATION:
Leaflet (flavours for dairy products)

CAMERA:
4 x 5in
LENS:
300mm macro
LIGHTING:
High-speed flash

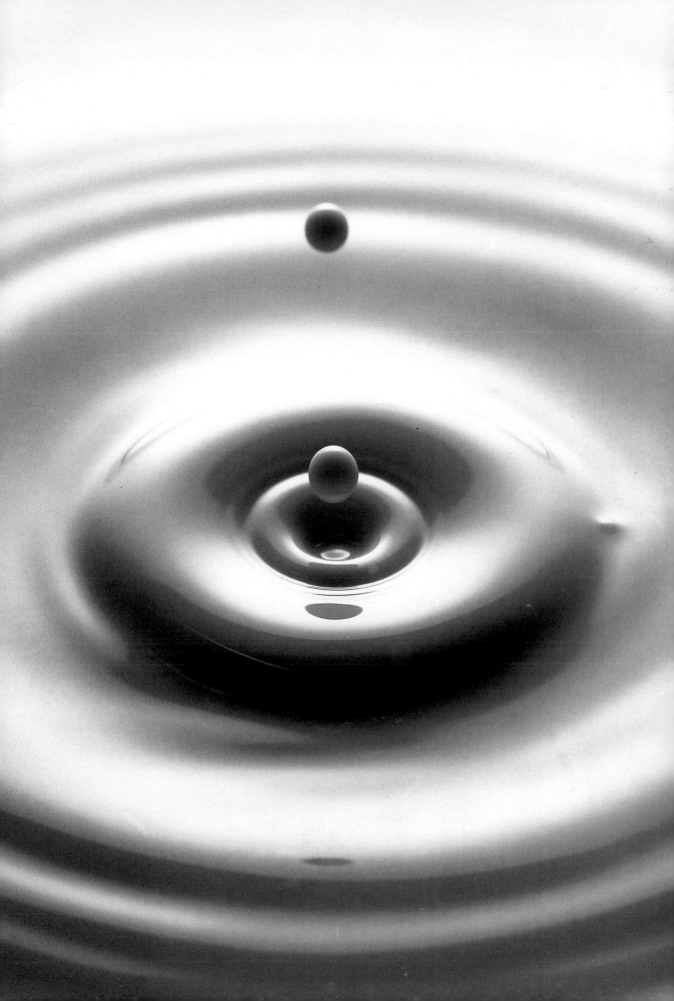

CLIENT:
**Givaudan-Roure
SA (flavour
manufacturer)**
APPLICATION:
**Leaflet (flavours
for soft drinks)**
CAMERA:
4 x 5in
LENS:
300mm macro
LIGHTING:
Flash

CLIENT:
**Swiss Meat
Promotion, Bern**
APPLICATION:
Poster
CAMERA:
4 x 5in
LENS:
300mm macro
LIGHTING:
Flash

Directory of photographers

Gary Benson
c/o Comstock Inc
28 Chelsea Wharf
15 Lots Road
London SW10 0QQ
UK
Telephone: + 44 (171) 3514448
Fax: + 44 (171) 3528414
Photograph on page 87

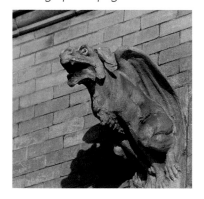

Denner Bryan
c/o Comstock Inc
28 Chelsea Wharf
15 Lots Road
London SW10 0QQ
UK
Telephone: + 44 (171) 3514448
Fax: + 44 (171) 3528414
Photographs on pages 131, 136

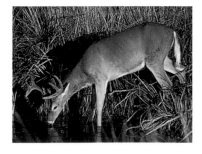

Sharon Chester
c/o Comstock Inc
28 Chelsea Wharf
15 Lots Road
London SW10 0QQ
UK
Telephone: + 44 (171) 3514448
Fax: + 44 (171) 3528414
Photograph on page 133

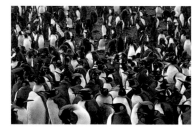

Ted Clark
Silver Birches
95 Yeovil Road
Sandhurst
Berkshire GU47 0QH
Telephone: + 44 (1276) 31803

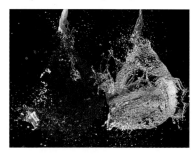

Ted Clark's interest in photography was first fired in 1957 when he purchased a home-made photographic enlarger from a jumble sale constructed from an old 'Cow & Gate' dried milk tin. This unlikely start prompted Ted to purchase his first camera – a Boots Bencini – progressing later to a Kodak Retinette. His first single lens reflex camera was a Zeiss Contaflex. Using this SLR, Ted began submitting work and, after much perseverance, he landed regular freelance work with a local newspaper, the *Barnes & Mortlake Herald*, in his spare time while working full time for a photographic retailers in Richmond, Surrey.

Ted's particular interest in photographing people and candid work led him to work for a private detective agency – 'a very interesting aspect of my career' – and later he was to spend many years covering weddings and portrait photography for a studio in Hampton Court. This phase of Ted's career put him on more of a sound financial foundation and allowed him to purchase a Hasselblad. Over the years he has tried and used many different cameras, finally settling for a Pentax, which he finds small and reliable, and with excellent optics. His current preference in the medium format range is a Bronica ETRS, and his most generally useful lenses are a

20mm wide-angle and medium-range zoom for animal subjects, which have always been a field of photography Ted enjoys. Ted's preference for film stock is Fujichrome for slide work and Fujicolor for prints.

Photographs on pages 50, 51

Hartman DeWitt
c/o Comstock Inc
28 Chelsea Wharf
15 Lots Road
London SW10 0QQ
UK
Telephone: + 44 (171) 3514448
Fax: + 44 (171) 3528414
Photograph on page 117

Alf Dietrich
Stadelhoferstrasse 28
CH-8001 Zurich
Switzerland
Telephone: + 41 1 2616740
Fax: + 41 1 2527096
Photographs on pages 143, 144, 145, 146, 147, 148, 149, 150, 151, 152, 153

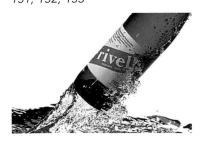

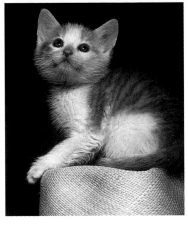

Robert Digiacomo
c/o Comstock Inc
28 Chelsea Wharf
15 Lots Road
London SW10 0QQ
UK
Telephone: + 44 (171) 3514448
Fax: + 44 (171) 3528414
Photograph on page 138

Laura Elliott
c/o Comstock Inc
28 Chelsea Wharf
15 Lots Road
London SW10 0QQ
UK
Telephone: + 44 (171) 3514448
Fax: + 44 (171) 3528414
Photograph on page 111

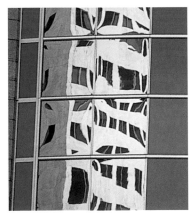

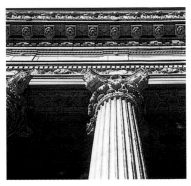

Jack Elness
c/o Comstock Inc
28 Chelsea Wharf
15 Lots Road
London SW10 0QQ
UK
Telephone: + 44 (171) 3514448
Fax: + 44 (171) 3528414
Photographs on pages 89, 94

Gwen Fidler
c/o Comstock Inc
28 Chelsea Wharf
15 Lots Road
London SW10 0QQ
UK
Telephone: + 44 (171) 3514448
Fax: + 44 (171) 3528414
Photograph on page 128

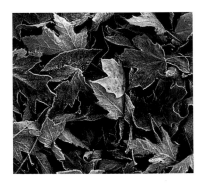

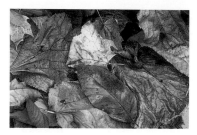

Henry Georgi
c/o Comstock Inc
28 Chelsea Wharf
15 Lots Road
London SW10 0QQ
UK
Telephone: + 44 (171) 3514448
Fax: + 44 (171) 3528414
Photograph on page 127

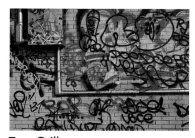

Art Gingert
c/o Comstock Inc
28 Chelsea Wharf
15 Lots Road
London SW10 0QQ
UK
Telephone: + 44 (171) 3514448
Fax: + 44 (171) 3528414
Photograph on page 135

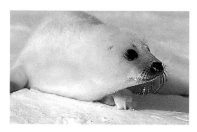

Tom Grill
c/o Comstock Inc
28 Chelsea Wharf
15 Lots Road
London SW10 0QQ
UK

Telephone: + 44 (171) 3514448
Fax: + 44 (171) 3528414
Photographs on pages 2, 18, 28, 31, 34, 61, 72, 73, 74, 79, 85, 108, 110, 119, 120, 129, 134

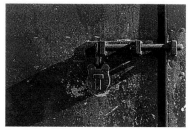

Simon Hennessey
11 The Sheepfold
Peacehaven
East Sussex BN10 8EG
UK
Telephone: + 44 (1273) 582309

Simon Hennessey studied photography at Epsom School of Art and Design for two years, leaving with a Datec diploma with distinction in audiovisual photography. His time immediately after leaving college was taken up with freelance photography for a local newspaper, taking on portrait and wedding commissions whenever opportunities arose. Simon returned to college in 1984 to take an SIAD diploma in photography, working during the two-year course with the fire service as a press and forensic photographer. On finishing the diploma course, Simon worked as a freelance photographer on several papers while retaining his links with the fire service. His big career move came in 1988 when he moved into the print trade and, then, into book publishing. *Photographs on pages 69, 83*

Madeleine Hilton
63 Greenham Road
London N10 1LN
UK
Telephone: + 44 (181) 4445882
Fax: + 44 (181) 4443551
Photograph on page 99

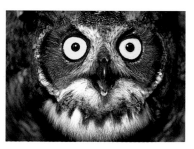

Russ Kinne
c/o Comstock Inc
28 Chelsea Wharf
15 Lots Road
London SW10 0QQ
UK
Telephone: + 44 (171) 3514448
Fax: + 44 (171) 3528414
Photograph on page 137

Paul Kirk
c/o 14 Springcroft Avenue
London N2 9JE
UK
Telephone: + 44 (181) 4443968
Fax: + 44 (181) 4443380
E-mail: dbootle@dircon.co.uk

It was during Paul Kirk's time at University of New York, where he was studying cinematography, that he first enrolled on a part-

time stills photography course as a filler, because he had exhausted all the other film courses available. At that time, he was working in black and white and treated the whole business rather light-heartedly. Nowadays, his interest is firmly in colour stills photography, but the sense of fun remains his prime motive.

On leaving university with an arts degree, Paul experienced periods of unemployment punctuated by stints working as a bar-tender, painter and decorator, and furniture-mover. Rather than wasting his periods of enforced leisure time, however, he put them to good use developing his interest in stills photography. In the past, Paul tackled portrait and landscape photography and supplemented his income with the sale of his prints, but his primary interest, as the pictures in this book demonstrate, has been with architectural aspects of the environment. 'I shot some landscapes but living in New York that became impossible. I like to think of my images as the landscapes you would find in a city.' More recently, Paul has moved out of New York City and is now living in the country. His photographic interests have increasingly become concerned with nature and wildlife subjects,

which, in large part, precipitated the move.
Photographs on pages 26, 96, 97, 98, 100, 102, 104, 106, 107

George Lepp
c/o Comstock Inc
28 Chelsea Wharf
15 Lots Road
London SW10 0QQ
UK
Telephone: + 44 (171) 3514448
Fax: + 44 (171) 3528414
Photograph on page 20

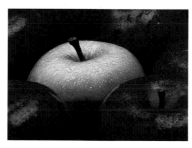

Phiz Mezey
c/o Comstock Inc
28 Chelsea Wharf
15 Lots Road
London SW10 0QQ
UK
Telephone: + 44 (171) 3514448
Fax: + 44 (171) 3528414
Photograph on page 32

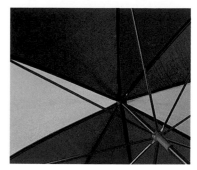

Bob Pizaro
c/o Comstock Inc
28 Chelsea Wharf
15 Lots Road
London SW10 0QQ
UK
Telephone: + 44 (171) 3514448
Fax: + 44 (171) 3528414
Photographs on pages 20, 25, 86

David Prior
PO Box 783961
Sandton 2146
South Africa
Photographs on pages 1, 7, 160

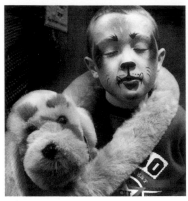

Linda Sole

33 Coleraine Road
London SE3 7PF
UK
Telephone: + 44 (181) 8588954
Fax: + 44 (171) 7398840

Born in 1943 in County Durham, Linda Sole now lives and works in southeast London earning her living as a freelance photographer concentrating principally on reportage and photo-documentary. Linda joined the Independent Photographers' Project in 1983, organizing workshops and photographic local events. Teaching photography has been a strand running through Linda's career, and she has taught and lectured on photography at various schools and colleges in Britain and abroad. She was also resident photographer at Blackheath Concert Halls between 1991 and 1993, where she held two exhibitions of her work. She also taught photography in France while working for a theme holiday company. As well as exhibiting regularly at Hays Gallery in Deptford, London, Linda is also

the winner of numerous photographic competition awards.
Photographs on pages 59, 62, 64, 66

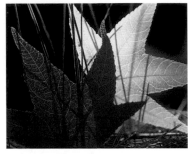

Mike Stuckey

c/o Comstock Inc
28 Chelsea Wharf
15 Lots Road
London SW10 0QQ
UK
Telephone: + 44 (171) 3514448
Fax: + 44 (171) 3528414
Photographs on pages 8,16, 23, 24, 27, 29, 39, 36, 38, 40, 53, 54, 55, 63, 70, 77, 88, 90, 101, 118, 139

Carlos Valdes-Dapena

c/o Comstock Inc
28 Chelsea Wharf
15 Lots Road
London SW10 0QQ
UK
Telephone: + 44 (171) 3514448
Fax: + 44 (171) 3528414
Photograph on page 93

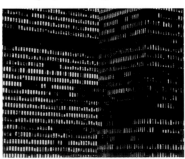

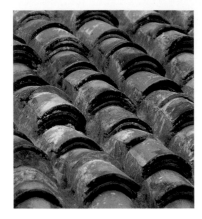

Franklin Viola

c/o Comstock Inc
28 Chelsea Wharf
15 Lots Road
London SW10 0QQ
UK
Telephone: + 44 (171) 3514448
Fax: + 44 (171) 3528414
Photographs on pages 84, 135

Bert Wiklund

PO Box 142
DK-7330 Brande
Denmark
Telephone: + 45 97 18 23 35
Fax: + 45 97 18 39 13

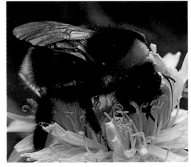

Bert Wiklund was born in Sweden 45 years ago, but he has been working as a professional photographer in Denmark for the last 20 years. Bert's academic background is in economics and social science and he has no formal training as a

photographer – he says: 'You can't get a formal degree in photographing nature anywhere in the world yet.' With his vast experience in, and love of, nature photography, his current client list is mainly composed of specialist magazines and books, but his interests also extend to the world of advertising photography. 'Everybody likes to have a green image today,' Bert wryly remarks.

Bert finds nature photography the most wide ranging of the photographic disciplines, extending, in his own words, 'from bacteria to galaxies'. To cope with this broad spread of subject matter, Bert finds himself using a range of different camera types and formats: a 35mm Nikon, a medium format Pentax, and even a half-plate camera when detail and quality are paramount. For more specialized imagery, his arsenal also contains panoramic and underwater cameras.

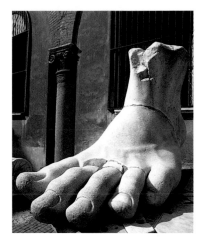

'Pictures of nature and of animals are difficult to predict and plan for in advance. You have to grab each opportunity as it arises.' Today, this policy has created for Bert a photographic archive of more than 150,000 pictures from every continent on the planet. And to make picture selection as easy as possible for potential clients, a 10,000-picture compact disc can be sent out to give a flavour of the type of imagery available.

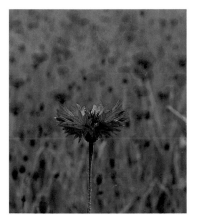

Photographs on pages 17, 39, 42, 43, 44, 45, 46, 48, 49, 52, 91, 114, 115, 122, 123, 124, 125, 129

Acknowledgements

In large part, the production of this book was made possible only by the contributions of the many photographers featured, some of whom permitted their work to be published free of charge, and the publishers would like to acknowledge their most valued contribution.

The author would also like to thank the following organizations and individuals for their support and technical assistance and services, in particular Brian Morris and Barbara Mercer at RotoVision SA, Anne-Marie Ehrlich of E. T. Archive and the equipment manufacturers whose equipment appears in this book.

All of the illustrations in this book were drawn by Brian Manning.

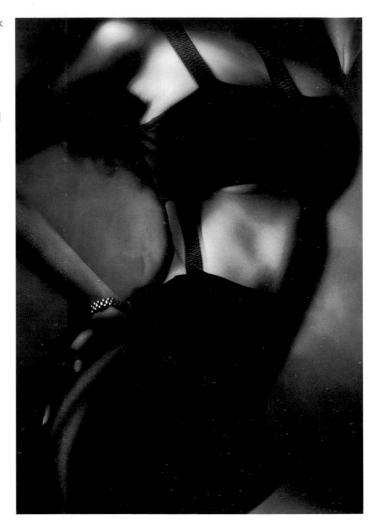